IMAGES
of America

TACOMA'S
LINCOLN DISTRICT

IMAGES
of America

TACOMA'S
LINCOLN DISTRICT

Kimberly M. Davenport

ARCADIA
PUBLISHING

Published by Arcadia Publishing
Charleston, South Carolina

Printed in the United States of America

Library of Congress Control Number: 2017956944

For all general information, please contact Arcadia Publishing:
Telephone 843-853-2070
Fax 843-853-0044
E-mail sales@arcadiapublishing.com
For customer service and orders:
Toll-Free 1-888-313-2665

Visit us on the Internet at www.arcadiapublishing.com

*For Harmon O. Davenport (1916–1991), Lincoln High School class
of 1935, noted Tacoma commercial artist, and my grandfather*

CONTENTS

ACKNOWLEDGMENTS

Tacoma has been home to my family for several generations. That said, my own childhood was spent in Seattle. It was as an adult, making the choice to return to Tacoma, that I settled in the Lincoln District. Before I thank the many people who have helped me to bring this book to fruition, I acknowledge the role the Lincoln District itself has played in nurturing my love of Tacoma's history. My home of nearly 20 years was built by Claude Gray, founder of Gray Lumber, which is still thriving as a family business after more than a century. He chose the location for his family home because of its view of Lincoln High School; Gray was proud of having served on the school board when the site for the new south-side high school was selected. Living amongst such constant reminders of Tacoma history has fueled my passion for researching the "City of Destiny." Thank you to my parents for sharing this Lincoln District journey with me.

The majority of the images in this book were gathered from the Tacoma Public Library's Northwest Room, where I enjoyed support from Ilona Perry, Jeanie Fisher, and Brian Kamens. Special thanks to Jennifer, Scott, and Dave Feist, third-generation owners of Lincoln Hardware, for the photographs you have shared and for your many years of friendship. Thank you to the Shanaman Sports Museum, and specifically Marc Blau, for providing photographs of Lincoln High School athletes. Thank you to Melissa McGinnis of Metro Parks for sharing your research into Lincoln Park. Thank you to Lee Hale, Lincoln High School class of 1941, for the many stories and photographs. Thank you to Nathan Gibbs-Bowling, Kevin Le, Andy Chen, and Leslie Young—Lincoln District enthusiasts all—for your time and support.

Finally, my deepest gratitude to Joe Chynoweth for your friendship, for always challenging me, and for sharing your passion for history.

INTRODUCTION

To explore the history of the Lincoln District is to experience a wide range of fascinating stories. What was in 1880 largely forest is today a vibrant and diverse urban area; there are many intriguing details behind how and why this dramatic physical transformation took place. As we investigate this history, there are myriad opportunities to consider how some of the major events and social movements of the 20th century were witnessed by those in the Lincoln District. Perhaps most importantly, there are stories of countless unique and interesting people: Lincoln District residents and business owners, Lincoln High School teachers and students, and prominent figures who have visited the area. Only some of these can be shared in this short book.

When explored through photographs, these stories can truly come alive in the form of glimpses into a community's shared past. Today, that community consists of the residential neighborhoods which surround Lincoln High School and the business district centered on South Thirty-Eighth Street. For the purposes of this book, the Lincoln District's boundaries are defined as Pacific Avenue to the east, M Street to the west, Fortieth Street to the south, and Interstate 5 and the remnants of historic gulches to the north.

The first chapter, "Neighborhood Namesake," explores the origins of the district. In the 1880s, development was taking place throughout Tacoma to accommodate the boom in population expected due to the city being selected as the western terminus of the Northern Pacific Railroad. In 1883, a trail was blazed from Fern Hill to downtown Tacoma; when it reached a steep gulch just south of downtown, this trail took a turn at what would later become South Thirty-Eighth Street in order to meet up with Pacific Avenue. By 1890, the intersection of Thirty-Eighth Street and Yakima Avenue would be a crossroads for two different streetcar lines, thus establishing the heart of the neighborhood's business district. In 1885, the Tacoma Land Company logged and cleared 100 acres in the area, eventually making room for residential development, and donated 40 additional acres to the city to be used as a park. When, in 1901, this park was renamed in honor of President Lincoln, the area found its identity.

Chapter two, "A School for the South Side," begins with the construction of Lincoln Park High School in 1913. The school's name would be shortened to Lincoln High School after just a few years, but the original name was a logical choice at the time, given the fact that a significant portion of the park was given over to provide land on which to build the new school. The bold choice by architect Frederick Heath to model the facility after Eton College in England would give the neighborhood a dramatic centerpiece. The welcoming auditorium entrance made clear that the building was not just a school but also a community gathering place; the substantial clock tower is a landmark visible throughout the district. This chapter also shares the story of the Lincoln statue erected in 1918, as well as images from throughout the 1920s. The stories of school and statue loom large, but this is also the decade in which a majority of the homes in the area were built.

The title of chapter three, "A Community Thrives in Challenging Times," reveals the overwhelmingly positive bent of the photographs of the Lincoln District that survive from the

Depression-era 1930s. In spite of what we know to be a time of high unemployment and bleak prospects for many families and business owners, extant images tell stories of a community coming together at every possible turn to support one another. Boosters of businesses on 38th Street began a tradition of parades, complete with turkey races, that would continue for many years. Highly successful programs in music and journalism at Lincoln High School brought national accolades, not to mention hope and pride, to a generation of students. And although it would be many years before it would come to fruition, the community began to plan and gather support for the Lincoln Bowl to rival Stadium High School.

Chapter four, "Finishing the Bowl and the Fifties Boom," shares the story of the Lincoln District during the period of postwar prosperity, the late 1940s and 1950s. As was true across Tacoma, and indeed the region and the nation, this was a time of substantial development, and the Lincoln District was no exception. The completion of the long-delayed Lincoln Bowl project was perhaps the single most important such event, but there were many other large building projects, including a fine arts building added to the high school and a new tuberculosis sanatorium on Pacific Avenue. Many new businesses opened, most of the small, family-owned variety, as was the tradition in the Lincoln District.

The final chapter, "Reinvention, Renovation, Revitalization," marches quickly through several decades, sharing a few last stories that serve to connect the Lincoln District's past to its present. On the surface, it could be possible to see nothing but change. When Interstate 5 cut through Tacoma in the early 1960s, it transformed the northern border of the Lincoln District forever. Demographic shifts within Tacoma, as well as waves of immigrants from around the world, have transformed what was once a homogenous area into a district that today prides itself on its diversity. And yet, in spite of so much change, there are also several important constants. Lincoln High School was substantially renovated in 2007, restoring the historic structure while insuring it can continue to serve students for generations to come. Although the business district now has an international flavor, far from its original start, the businesses remain small and family-run. Those who choose to live in the district, whether longtime residents or new arrivals, take pride in their humble but well-built homes and find inspiration in the fact that the Lincoln District remains rooted in its history as it continues to reinvent itself for the future.

One

NEIGHBORHOOD NAMESAKE

In 1889, the Tacoma Land Company—the Northern Pacific Railroad's land development operation—donated to the city of Tacoma 40 acres of land for use as a park for south-end residents. The park was originally known as South Park, but in 1901, the Tacoma Park Commissioners officially changed the name to Lincoln Park in honor of Pres. Abraham Lincoln. This chapter begins with several images of the park in its original design and configuration—substantially larger and more developed than what remains today, after portions of the park were gradually cut away for other projects. Also shared in this chapter are images of the first significant structures in the area, such as schools, churches, and a fire station. Most of these buildings will not be familiar to the modern eye, having been long since demolished and replaced.

Finally, some of the images shared here serve to connect the foundations of the Lincoln District to that of Tacoma as a whole. Although it is no longer a prominent landmark, having been capped during Interstate 5 construction, the Hood Street Reservoir was an important early addition to Tacoma's water system. Galliher's Gulch, which originally formed the natural northern border of the Lincoln District, was once home to a bicycle bridge that connected neighborhoods to the south and east to downtown. It was also the site, tragically, of the nation's deadliest trolley disaster on July 4, 1900.

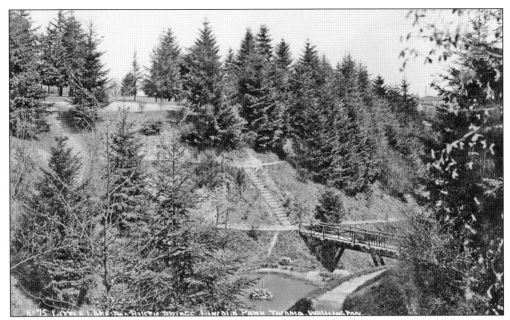

When Lincoln Park was dedicated, the public was skeptical that the gulch, with its steep slopes and native plants growing wild, was a suitable area for a park. As this postcard photograph from 1916 reveals, however, the gulch was successfully sculpted into a series of paths. By 1903, the *Daily Ledger* would describe it as "one of the most picturesque ravines in the West." (Courtesy of Tacoma Public Library.)

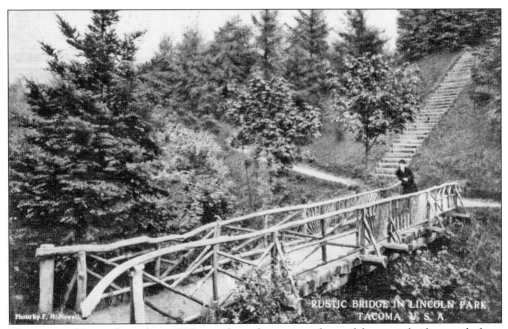

This postcard image from about 1915 provides a closer view of one of the rustic bridges made from trees taken from the gulch itself. Utilizing onsite materials to develop the park was a common strategy of Tacoma Parks superintendent Ebenezer Roberts, who planned and managed the development of Lincoln Park in these early years. (Courtesy of Tacoma Historical Society.)

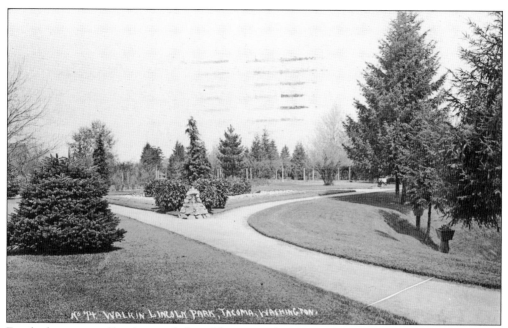

For the large area of level ground along Thompson Avenue, Roberts saw the potential for flower gardens, a playground larger than was currently available to children anywhere in Tacoma, and, as seen in this postcard photograph from about 1915, walking paths to be enjoyed by visitors of all ages. (Courtesy of Tacoma Public Library.)

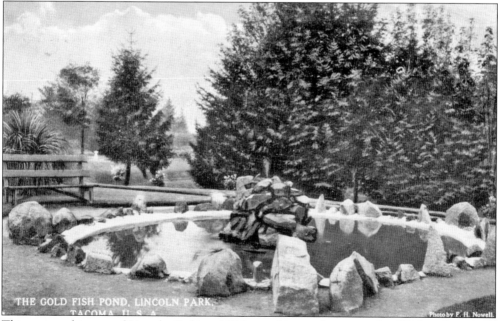

This postcard image of Lincoln Park's goldfish pond is another example of Roberts's reuse of materials from within the park, in this case a variety of rocks collected to surround the pond. Quoting again from the *Daily Ledger* in 1903, "By utilizing this waste material, so to speak, good results, the very best results indeed, are obtained at almost no cost." (Courtesy of Tacoma Historical Society.)

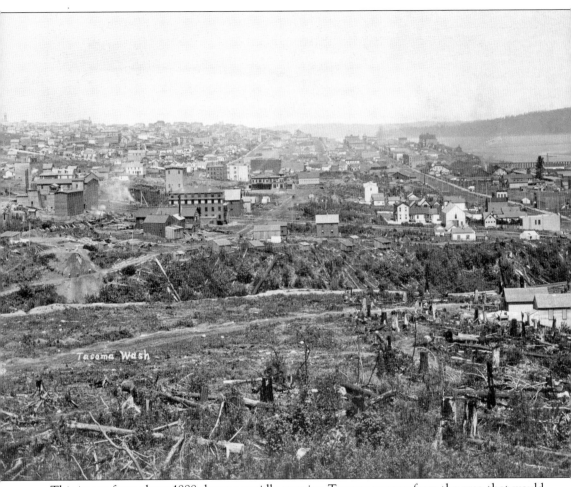

Tacoma Wash

This image from about 1888 shows a rapidly growing Tacoma as seen from the area that would later become known as the Lincoln District. In the foreground are many recently cut trees and a few small houses perched above Galliher's Gulch. Directly across the gulch is the area that would become Tacoma's brewery district. The wide street at the far right of the image is Pacific Avenue, then and now a connection between the Lincoln District and downtown Tacoma. In the distance, from left to right, is a densely populated housing district, the downtown core, and Commencement Bay. In spite of the multitude of changes that have altered this view, the image serves to illustrate something that remains true today: the Lincoln District enjoys a close proximity to downtown and yet remains a distinct neighborhood because of the natural boundary created by the gulch. (Courtesy of Tacoma Public Library.)

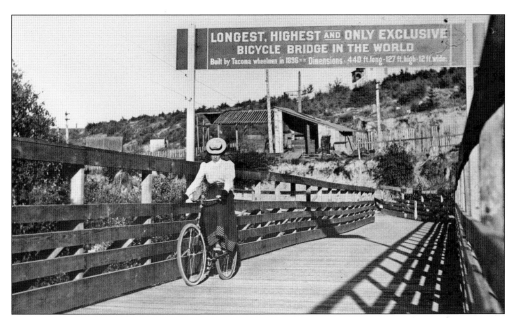

Around 1900, a young woman was photographed riding her bicycle across Galliher Gulch Bridge, which was constructed in 1896 by the Tacoma Wheelmen's Bicycle Club. It was near Holy Rosary Church, connecting Delin Street with the path leading to the Hood Street Reservoir. A large sign above the bridge proclaimed it to be the "longest, highest and only exclusive" bicycle bridge in the world. (Courtesy of Tacoma Public Library.)

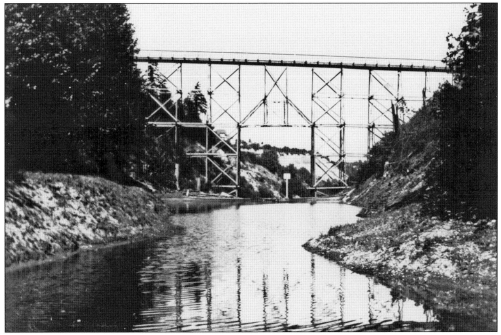

This view of the Galliher Gulch Bridge, also known as the Tacoma Bicycle Bridge, was captured around 1896. The bridge was 440 feet long, 127 feet high, and 12 feet wide and was built with funds accrued from the sale of bicycle licenses. The bridge over the deep gulch enabled cyclists to travel undisturbed from Tacoma's Eastside to South Tacoma. (Courtesy of Tacoma Public Library.)

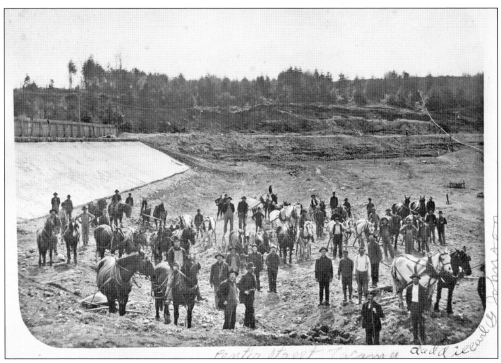

Supplying a growing Tacoma with a consistent and clean water supply was a challenging project that took decades to fully implement from the 1880s into the 1910s. One early solution was the creation of the Hood Street Reservoir on the hill just south of downtown, above Galliher's Gulch. The reservoir, 260 feet above sea level, held water from a variety of sources that could then be fed downhill to the downtown core. These two images, from about 1900, show the land being cleared and leveled in preparation for the construction of the reservoir, which was considered enormous at the time: 320 feet long, 113 feet wide, and filled to a depth of 14 feet. The reservoir remains a part of Tacoma's water system today, although it has been capped. (Both, courtesy of Tacoma Public Library.)

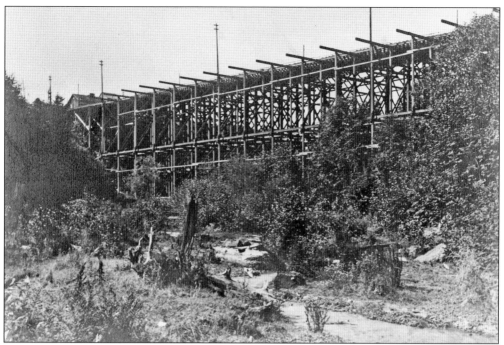

On July 4, 1900, Tacoma was the site of a horrific trolley disaster. Tens of thousands of revelers were expected for a major parade downtown, and many of those coming from south of the city center would arrive via streetcar. A trolley filled to three times its capacity made its final stop on Delin Street, near Holy Rosary Church, before starting again and eventually losing control as it passed over the trestle seen here, high above Galliher's Gulch. In spite of a valiant effort, the motorman was unable to stop the car from leaving the tracks and crashing down into the gulch below. Forty-four men, women, and children were killed in the accident. The damaged trestle was never used for streetcars again and was eventually torn down. (Both, courtesy of Tacoma Public Library.)

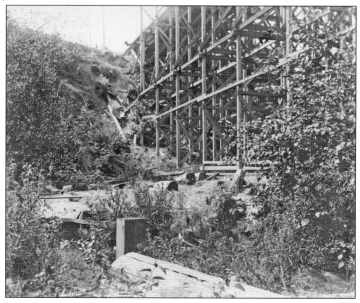

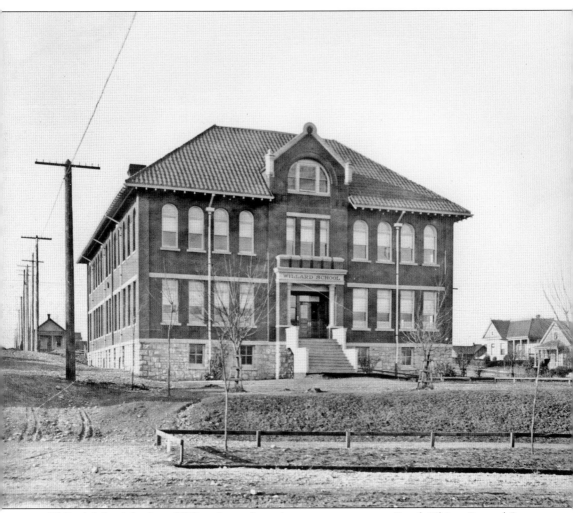

Willard School, built in 1899 and seen here the same year, was on South Thirty-Second Street one block off Pacific Avenue. The building was remodeled in 1908 under the guidance of architect Frederick Heath, who would later design Lincoln High School. Along with several other Tacoma schools, it was torn down after being damaged in the earthquake of 1949 and replaced on the same site with a new school building in 1952. Willard was the first school in Tacoma to be named after a woman, Frances E. Willard (1839–1898), a noted educator and suffragette whose influence was instrumental in the passage of the 18th and 19th Amendments to the US Constitution. Willard became the national president of the Woman's Christian Temperance Union (WCTU) in 1879 and remained president until her death in 1898. She developed the slogan "Do Everything" for the WCTU, encouraging its membership to engage in a broad array of social reforms. (Courtesy of Tacoma Public Library.)

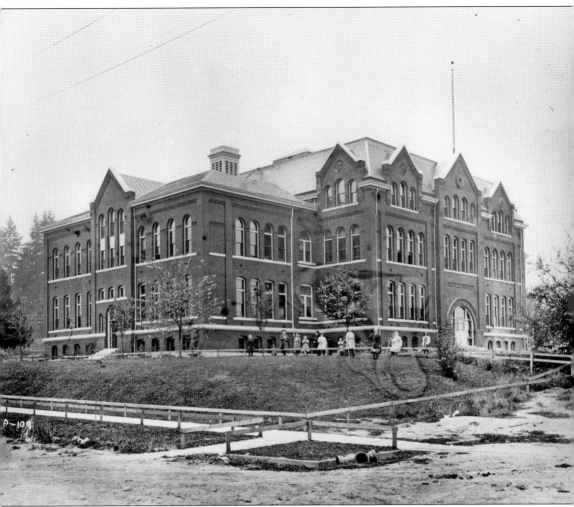

Whitman School was the first brick school built in Tacoma. This photograph is from 1894, two years after the school opened in March 1892 on South Fortieth Street just east of M Street. Children pose for the camera, and it also appears that concrete has recently been poured for new sidewalks between the school and the unpaved streets of the neighborhood. Early school board records indicate that the building was one of Tacoma's schools to be named for writers, including Bryant, Lowell, Emerson, Hawthorne, Whittier, and Irving. In 1949, however, school board president Fran Pratt declared the school to have been named for Narcissa and Marcus Whitman. Also in 1949, the building was heavily damaged by an earthquake, and it was demolished and replaced with a new facility that opened in 1951. (Courtesy of Tacoma Public Library.)

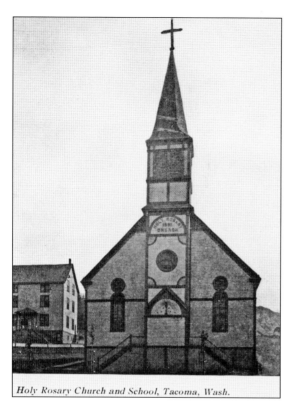

Holy Rosary Church and School, Tacoma, Wash.

In 1891, a group of German-speaking Catholics purchased a large plot of land on South Thirtieth Street and built a wooden church and school. On July 16, 1891, William Eversmann arrived in Tacoma as Holy Rosary's first pastor. The building pictured here would serve the congregation until the construction of a larger brick church on the same site in 1920. (Courtesy of Tacoma Public Library.)

A crowd gathers to celebrate the dedication of St. Joseph's Slovak Catholic Church on the corner of South Thirty-Fourth Street and Tacoma Avenue on May 19, 1912. At the time of its opening, St. Joseph's was the only Slovakian Roman Catholic parish west of the Mississippi River. Slovakian-language services were held until 1935. (Courtesy of Tacoma Public Library.)

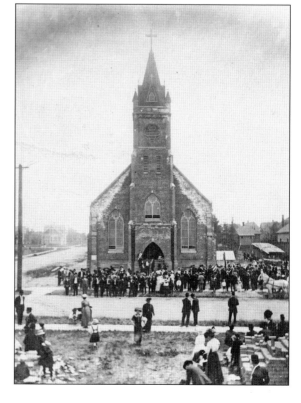

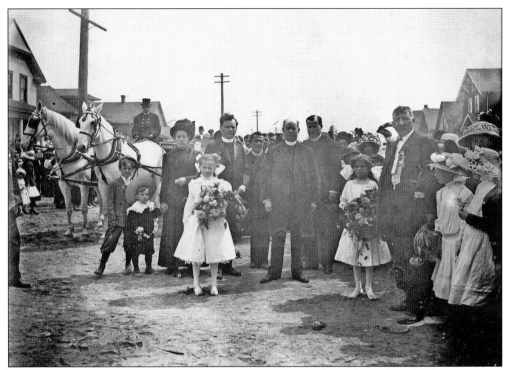

The dedication of St. Joseph's on May 19, 1912 was overseen by Bishop Edward J. O'Dea, center, assisted by Rev. Fr. Paul Kern and Rev. Aloysius Mlinar, rector. The church is out of view to the left in this photograph, which captures congregation members of all ages standing on Thirty-Fourth Street during the celebration. (Courtesy of Tacoma Public Library.)

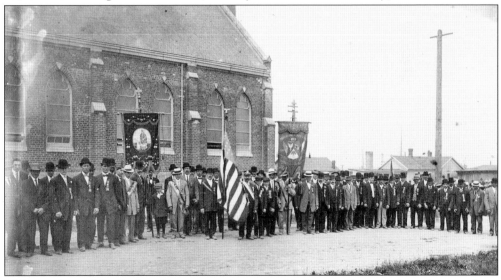

Male members of the St. Joseph's congregation pose with flags and banners for a photograph on Tacoma Avenue during the 1912 dedication with their new church in the background. As the church was built by members of the congregation, saving the church an estimated $10,000, it is likely that some of the men seen here had a hand in its construction. (Courtesy of Tacoma Public Library.)

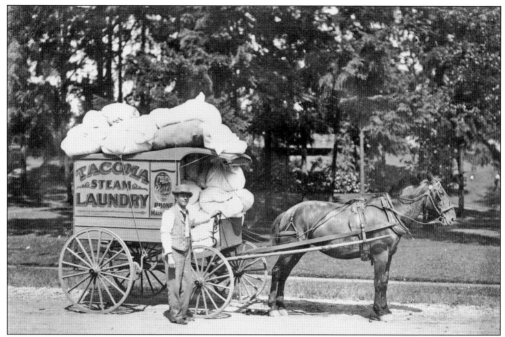

In this image from about 1910, a Tacoma Steam Laundry wagon is seen piled high with laundry awaiting delivery. Tacoma Steam Laundry operated from its large facility on Wright Avenue between Tacoma Avenue and G Street from 1910 until 1958, when the building was lost to fire. (Courtesy of Tacoma Public Library.)

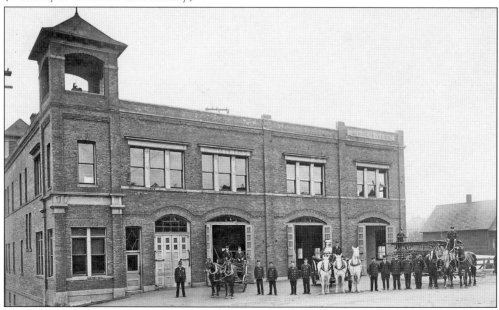

The men of Tacoma Fire Station No. 2 pose in 1907, the year of the station's opening. Their horse-drawn equipment included an 1889 Hayes 65-foot aerial, a Continental 2nd size steam fire engine, and hose wagon No. 2, an 1890 California apparatus. The station was substantially remodeled in the 1930s but remains in operation at this location, 2701 Tacoma Avenue South. (Courtesy of Tacoma Public Library.)

Two

A SCHOOL FOR THE
SOUTH SIDE

Such was the extent of the boom in Tacoma's population that, only a few years after the opening of Stadium High School in 1906, the Tacoma School Board was already discussing plans for a "south side high school." There was some public debate about where the new school should be located, but at a school board meeting on September 2, 1911, the decision was made to utilize land taken from Lincoln Park, building the new school at the corner of South Thirty-Seventh and G Streets. The school's cornerstone was laid on Labor Day, September 1, 1913, and the school opened to its first group of 850 students on August 31, 1914.

Plans for a statue of Abraham Lincoln to be erected on the campus date back to before the school's opening, but fundraising for the project would take several years. It was not until 1917 that a contract was signed with artist Alonzo Victor Lewis; the statue was finally dedicated on February 12, 1918. While the new school and its growing population of students certainly dominate this chapter, there is also much to share in terms of development in the surrounding neighborhoods and business district. Unfortunately, few photographs exist of individual homes, but newspaper accounts of the time attest to the fact that during the early 1920s, new homes were being built at the rate of nearly one per day.

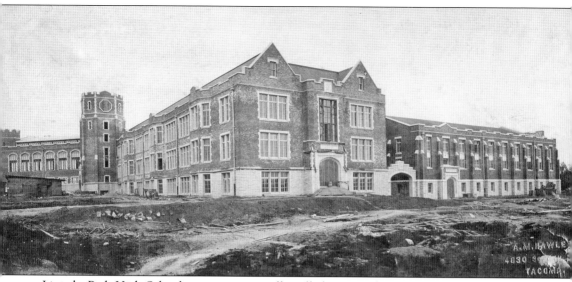

Lincoln Park High School, as it was originally called, is seen during construction. Architect Frederick Heath modeled Tacoma's second high school on Eton College in England, and there are many similarities, both general and specific, between the two structures. Both are brick with stone foundation, with cast stone framing around windows. More specifically, Heath chose to give Lincoln a clock tower and surrounded the auditorium (at left in this photograph) with two turret-topped pillars of brick, certainly not essential features for a high school but clearly emulating the Eton campus. One key difference reflects the Victorian influence on Heath's design. While most of the angles of Eton's buildings are square, Lincoln's auditorium juts out at an angle from the straight lines of the rest of the school, and the clock tower sits off-center in the building, neither completely imbedded in the structure nor completely self-standing. (Courtesy of Tacoma Public Library.)

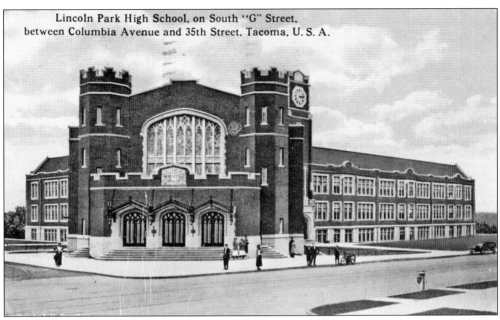

Lincoln Park High School, on South "G" Street, between Columbia Avenue and 35th Street, Tacoma, U. S. A.

Two images show Lincoln High School around 1920 as viewed from the intersection of G Street and Columbia Avenue, the latter now known as Thirty-Seventh Street. Three sets of double doors provide a welcoming entrance to the school's auditorium. The school was originally designed for a capacity of 800 to 1,000 students, with an estimated cost of about $225,000. With population growth projected in the area, however, the school board eventually authorized architect Frederick Heath to design a school to accommodate up to 1,800 students. When the cost of construction rose to a final tally of $436,607.68, there was some initial public criticism. Within a few years of its opening, however, the surrounding community took great pride in its new school. (Both, courtesy of Tacoma Public Library.)

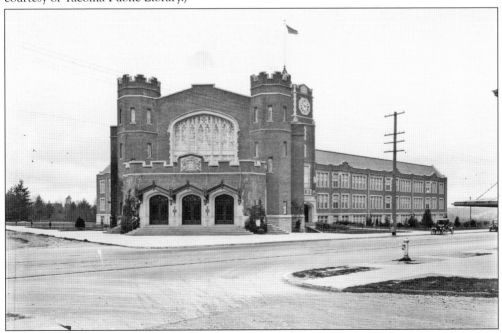

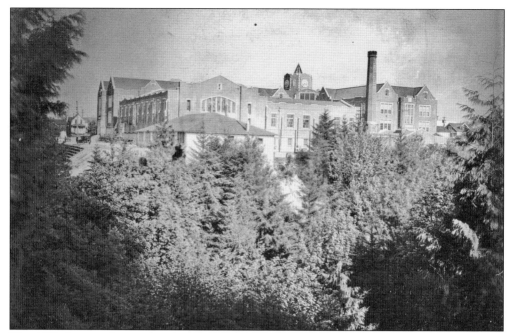

This 1922 photograph was taken from Lincoln Park, with the thickly forested gulch in the foreground and Lincoln High School in the background. Because most extant photographs of the school from this era are taken from the opposite angle, in front of the auditorium, this view provides a unique perspective on the size of the original campus. (Courtesy of Tacoma Public Library.)

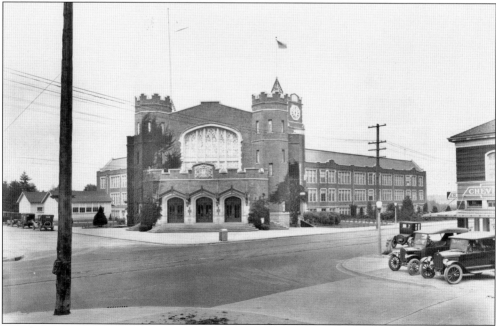

By 1930, when this picture was taken, portables had been added along Columbia Avenue to provide additional capacity for the growing Lincoln student body. At far right, across G Street from the school, is a retail building, constructed in 1914, which was at this time home to a Chevrolet dealership. (Courtesy of Tacoma Public Library.)

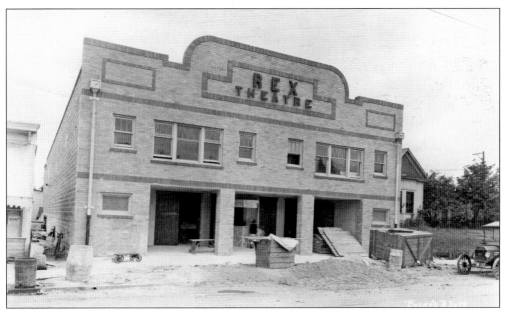

The Rex Theatre, for many decades the neighborhood theater for the Lincoln District, is seen during construction in 1919. Seeking to give his patrons the best possible movie experience, owner Martin Steffen had the theater built with a nursery where mothers could care for their small children and infants while still being able to view the screen. (Courtesy of Tacoma Public Library.)

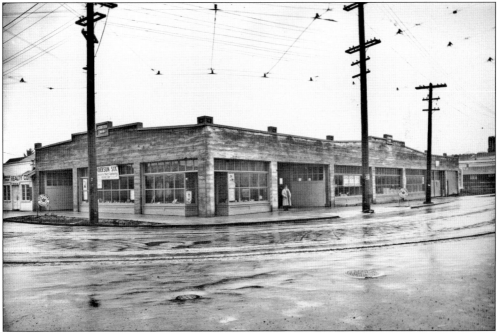

An unidentified man stands under cover for a rainy photograph of the J. Griffith Building, built in 1920 at the northwest corner of Thirty-Eighth and G Streets. Signage in the building's windows advertises the Anderson Six, described as the "Season's Most Captivating Motor Car." At far left is Lincoln High Realty Co., and at far right, one of Lincoln High School's auditorium's distinctive turrets can be seen. (Courtesy of Jennifer Feist.)

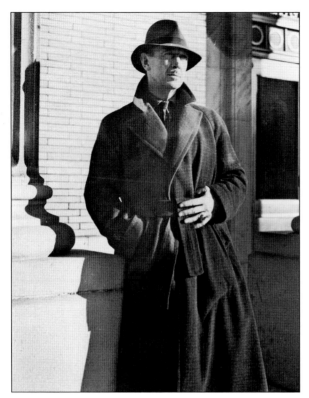

Local artist Alonzo Victor Lewis (1886–1946), pictured in 1937, was selected in 1914 to create a statue of Abraham Lincoln for the Lincoln campus. Born in Utah, Lewis studied at the Art Institute of Chicago before settling in Seattle in 1912. Lewis created many public sculptures in Washington State, including *Winged Victory* at the state capitol in Olympia and a Lincoln statue in Spokane. (Courtesy of Tacoma Public Library.)

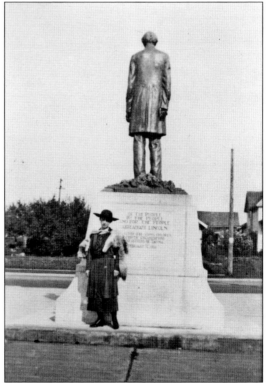

The inscription on the back of the statue, "Erected by the School Children, Patriotic Organizations, and Citizens of Tacoma," reflects the true community effort—led by Tacoma schoolchildren—that went into raising the $4,500 necessary for the creation of the statue. Thousands attended the statue's unveiling on Lincoln's birthday, February 12, 1918. (Courtesy of Tacoma Public Library.)

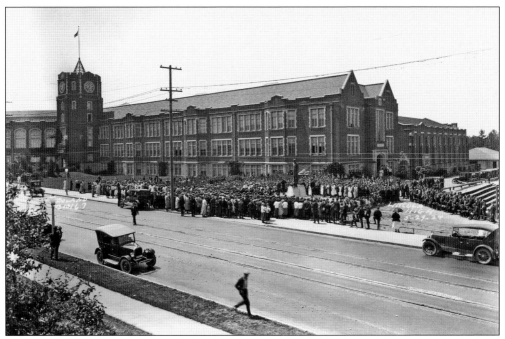

Lincoln High School students assemble around the school's statue of Abraham Lincoln on May 29, 1924, during a Memorial Day celebration. This image was captured from across G Street, which in this era carried not only cars but also streetcar trolleys. In addition to the few cars along G Street, many can be seen parked behind the school, above the bowl. (Courtesy of Tacoma Public Library.)

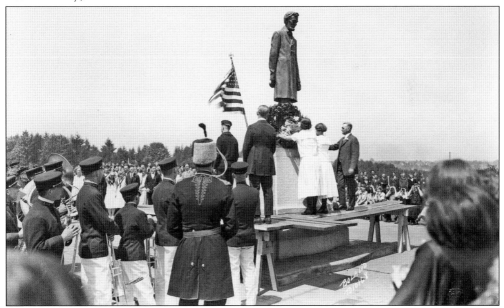

During the 1924 Memorial Day ceremony, Eunice Huseby (left) and Florence Anderson placed a floral wreath at the foot of the Lincoln statue. The girls, dressed in white skirts and blouses, stood on a makeshift platform. Lincoln students planned the ceremony, which was intended to honor the school's namesake as well as veterans. (Courtesy of Tacoma Public Library.)

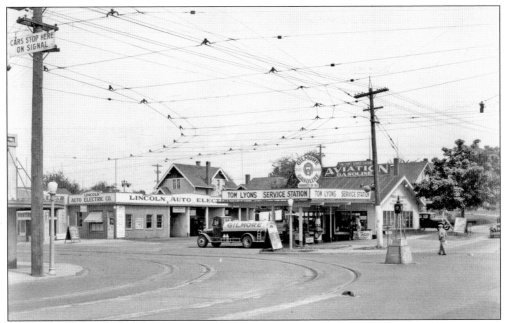

These two images from about 1930 capture the bustling intersection of South Thirty-Eighth and G Streets, where the streetcar line made a turn requiring a signal for automobiles to avoid collisions. Tom Lyons's service station occupies the northeast corner of the intersection, and a Gilmore Gasoline truck can be seen making a delivery. North of Lyons's along the east side of G Street is Lincoln Auto Electric Co., which, according to its signage, offered battery charging for 75¢ and a rebuild of a four-cylinder engine for $40. In one picture, a man is crossing Thirty-Eighth carrying what appears to be a bottle of milk. In the other, two women tend to a baby carriage near a trash receptacle advertising current attractions at downtown theaters. (Courtesy of Jennifer Feist.)

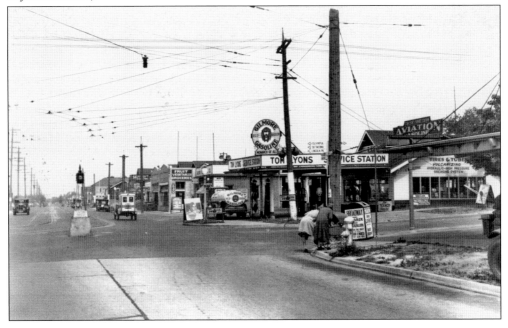

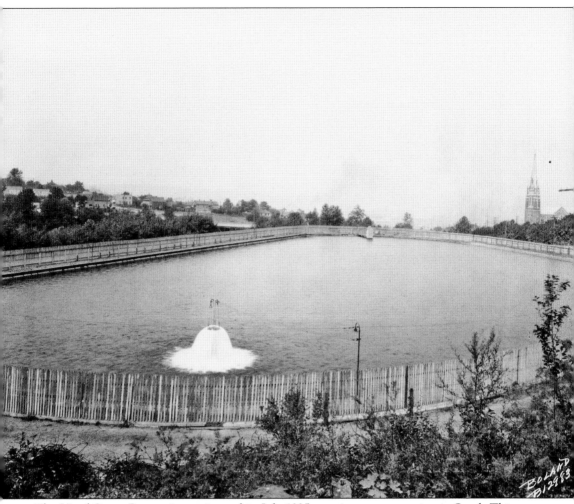

The Hood Street Reservoir, as pictured in July 1925, was in a serene setting at South Thirty-Second Street and Yakima Avenue, a few blocks north of Lincoln High School. In the foreground is an aerator, which is putting oxygen in the water to prevent the growth of anaerobic bacteria. The large concrete-lined basin had a capacity of 13 million gallons. In the background at left are several homes. At right is the distinctive steeple of the second Holy Rosary Catholic Church, which was dedicated in 1921. Occupying the same site as the congregation's previous wood-frame facility, built in 1891, the new church featured a dramatic 54-foot steeple, which placed the cross at its top at 270 feet above the ground. At the time of its opening, this new Holy Rosary Church was the tallest in Washington State. (Courtesy of Tacoma Public Library.)

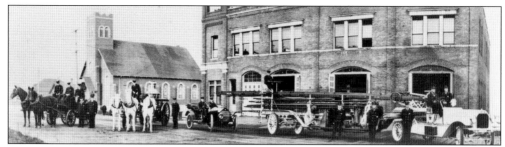

In this image from about 1920, the men and equipment of Engine House No. 2 are on display outside their station at Twenty-Seventh Street and Tacoma Avenue, with St. Paul's Evangelical Lutheran Church in the background. This was a period of transition for the Tacoma Fire Department, with horse-drawn engines working side-by-side with early ladder trucks. (Courtesy of Tacoma Public Library.)

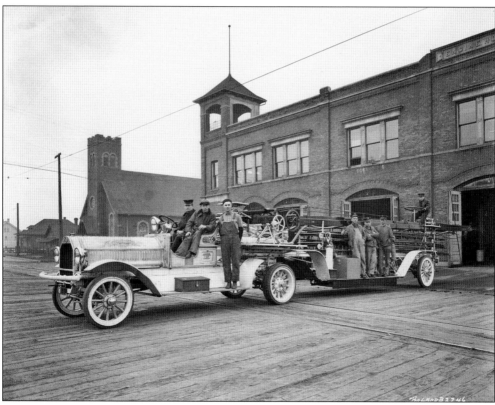

Driver Harry Ketler, tillerman Jim Turner, and other unidentified members of Truck Company No. 2 are pictured with their 1913 Seagrave 75-foot aerial in front of Engine House No. 2 in March 1920. The hose tower is in view. Note the planked roadway that is Tacoma Avenue South. (Courtesy of Tacoma Public Library.)

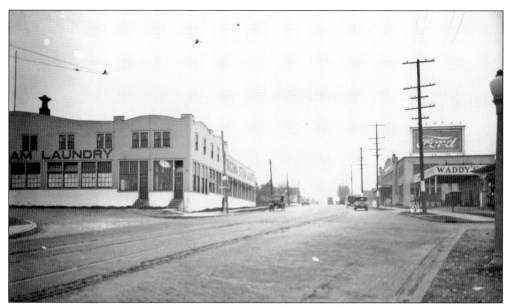

This is how the intersection of South Thirty-Third and G Streets looked on the evening of March 18, 1925, at 6:13 p.m. Several cars and a streetcar can be seen traveling on G Street. Tacoma Steam Laundry is the large building to the left on South Thirty-Third Street, and Waddy's Battery Hospital and Bye Thompson Motor Sales are at right. (Courtesy of Tacoma Public Library.)

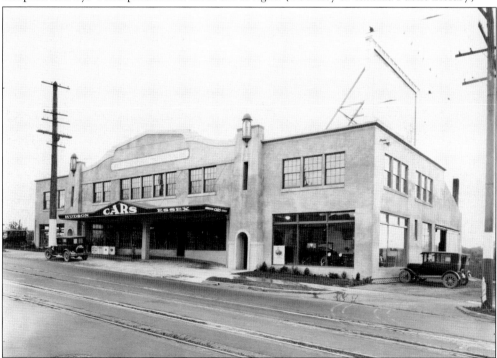

Bye Thompson Motor Sales opened this building at South Thirty-Third and G Streets in 1923 as a Ford dealership, and this picture was captured in June 1925, when the dealership was promoting cars by Hudson and Essex. The building was home to a variety of car dealerships through the 1940s. (Courtesy of Tacoma Public Library.)

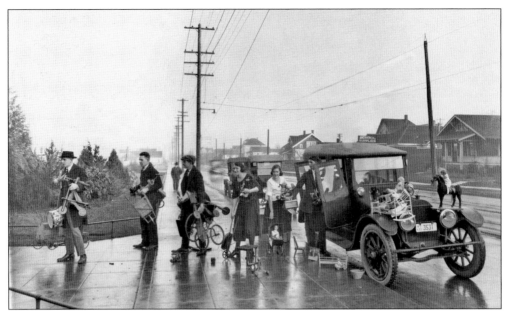

Members of the *Lincoln High School News* (from left to right, Carl Schmid, Lloyd Eberhart, Morrill Folsom, Constance Markuson, Norma Huseby, and John McKown) arrive at Lincoln on December 19, 1922, with used toys donated by fellow students. The newspaper staff hoped to make the toy drive an annual event. (Courtesy of Tacoma Public Library.)

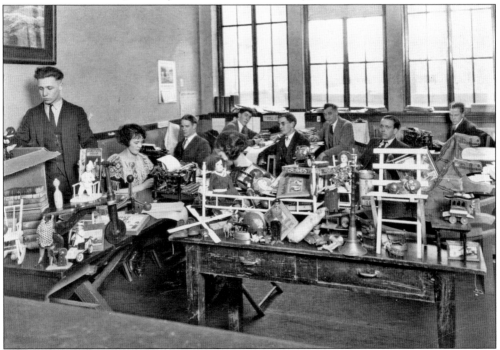

Once back at school, the students repaired toys ranging from bicycles and sleds to toy horses and hundreds of dolls, making them good as new for donation to local children in need. "Santa's Helpers," as they were called by the *Tacoma Ledger*, utilized skills gained in their shop, sewing, and art classes at Lincoln. (Courtesy of Tacoma Public Library.)

William Jennings Bryan, the famed orator, presidential candidate, and secretary of state (under Woodrow Wilson), visited Tacoma in September 1924. This picture was taken outside the Tacoma Hotel. His visit coincided with the first week of the school year in Tacoma, and Lincoln High School students were treated to a surprise visit, with Bryan speaking at an assembly in the school's auditorium. (Courtesy of Tacoma Public Library.)

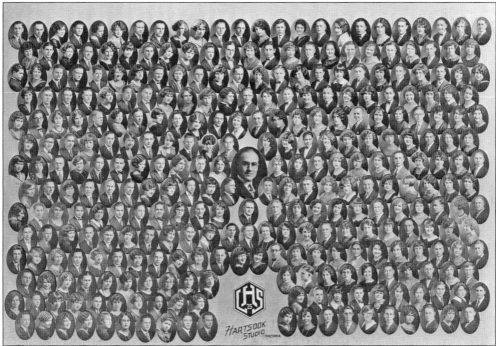

Many of the students who heard Bryan speak in September 1924 are likely in this image, which includes the senior portraits of every member of the Lincoln High School class of 1925. Hartsook Studio, which created the compilation image, had offices in the Rust Building in downtown Tacoma. (Courtesy of Tacoma Historical Society.)

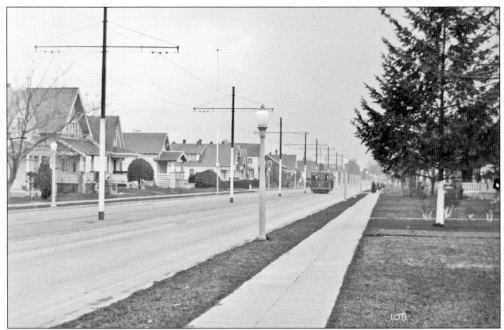

A streetcar trolley on its way from Fern Hill towards downtown Tacoma travels north on Yakima Avenue at approximately South Forty-Third Street in this photograph from the late 1920s. Along this stretch of Yakima is a mix of homes ranging from a few built in the 1890s and 1900s to Craftsman bungalows of the late 1910s or early 1920s. (Courtesy of Tacoma Public Library.)

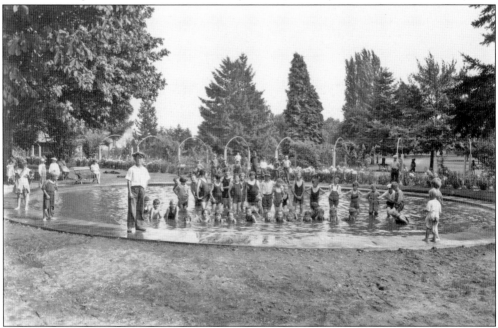

A large group of children, some in swimming suits and others in regular clothes, enjoy the circular Lincoln Park wading pool in late July 1926. Several large trees provide shade over the pool, and flower gardens can be seen in the background. Lincoln High School is partially hidden behind trees at left. (Courtesy of Tacoma Public Library.)

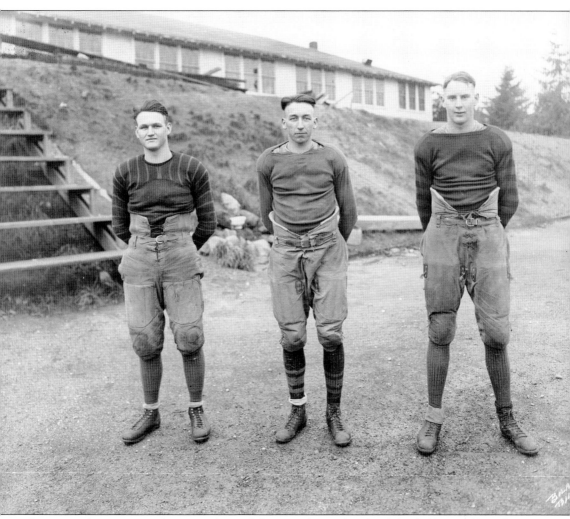

On November 19, 1924, three members of the Lincoln High School football team (from left to right, David Rice, James Mosolf, and Richard Johnson) posed for this photograph. Rice was senior class president, and Johnson would kick the winning field goal in the team's final game of the 1924 season. It was Mosolf, though, who would go on to play a very unique role in Lincoln High School history. He was elected by his fellow students in the spring of 1926 to travel by train from Tacoma to Washington, DC, to hand-deliver a telegrapher's key made by students in the shops at Lincoln to US president Calvin Coolidge. The president would use the key to formally mark the opening of Tacoma Power's Cushman Dam No. 1, one of the first major dams built in the Pacific Northwest. After leaving Lincoln, Mosolf would go on to play parts of four seasons of major-league baseball: 1929–1931 with the Pittsburgh Pirates and 1933 with the Chicago Cubs. (Courtesy of Tacoma Public Library.)

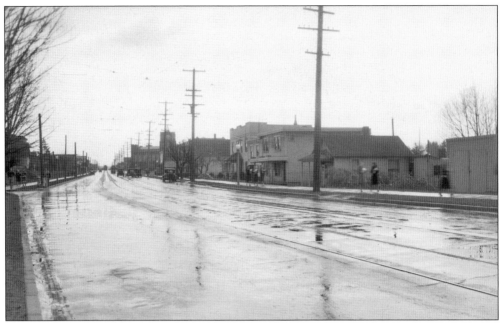

Lincoln High School is in the distance at right as several students walk to or from school on a rainy day in this photograph of South G Street looking south from about Thirty-Fifth Street. Remainders of the old brick street can be seen at left, underneath the newer pavement. The exact date of this photograph is unknown, but a streetcar is still sharing the road with cars. (Courtesy of Tacoma Public Library.)

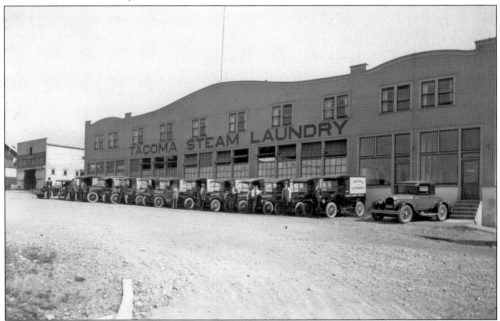

In June 1925, delivery drivers pose with their vehicles outside Tacoma Steam Laundry's impressive facility on Wright Street, which is not yet paved. Each vehicle is identified by a number and the tagline "Deluxe Laundry Service." To the left of the large laundry building is a small garage. (Courtesy of Tacoma Public Library.)

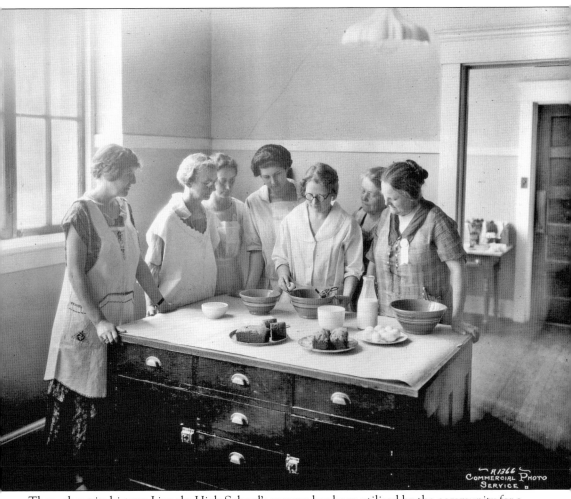

Throughout its history, Lincoln High School's campus has been utilized by the community for a range of activities. This picture was taken in the summer of 1925, when the Washington State College extension service sponsored its second annual vacation camp for Western Washington farm women at Lincoln. More than 50 women were enrolled from July 26 to 30, 1925, each representing a home economics club or community organization. The women took courses in home management, nutrition, and the making of apparel. Here, six women in aprons intently watch a teacher crack an egg in what appears to be a baking lesson. On the counter are bowls, milk, eggs, and finished baked goods. The *Tacoma News Tribune* reported that Lincoln was strictly off limits to men during the camp, and the women bunked on cots set up in the gym. They attended two classes each day, which left time for swimming, walking, and dancing. (Courtesy of Tacoma Public Library.)

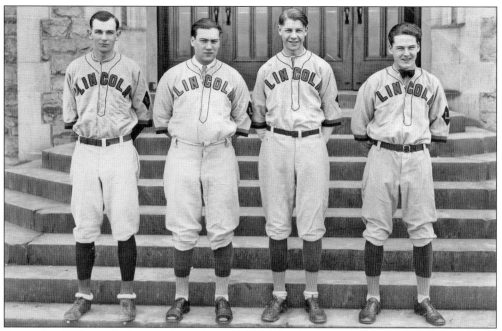

Since a baseball team had not yet been formed when the 1928 Lincoln yearbook went to print, this photograph of returning lettermen (from left to right, George Wise, Russell Kasselman, Harold Tollefson, and Jack Clark) appeared in the yearbook. Tollefson, class of 1928, played three sports, was on the *Lincoln News* staff, and appeared in two operas during his years at Lincoln. (Courtesy of Tacoma Public Library.)

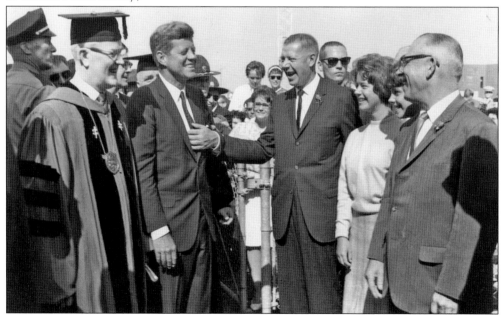

Harold Tollefson would go on to serve three terms as mayor of Tacoma. He is seen here to the right of Pres. John F. Kennedy during the president's visit to Tacoma in 1963. At far right is Harold's brother Thor, Lincoln class of 1924, who was Pierce County prosecutor before serving eight terms in the US House of Representatives. (Courtesy of Tacoma Public Library.)

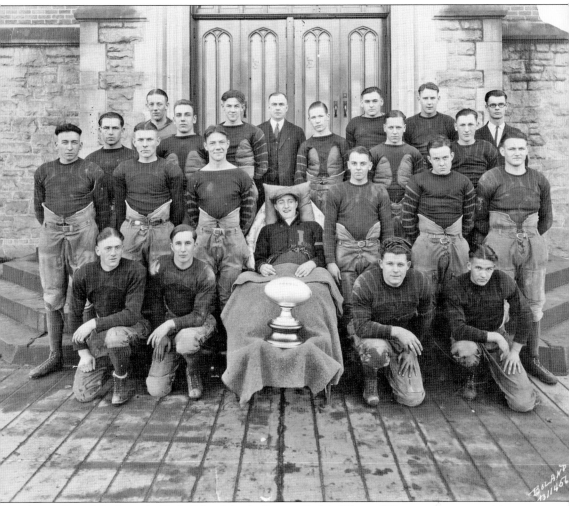

A member of the Lincoln High School football team, Ralph "Skinny" Burt, center, was stricken with polio during the summer of 1924. At first, doctors thought his illness was caused by a football injury, as he had crashed into a goalpost in a 1923 game at Stadium High School, but the diagnosis of polio soon followed. According to the 1925 yearbook, Skinny Burt's absence from the team was felt, but he did more than his share from the sidelines. In fact, at the end of the 1924–1925 season, Skinny was selected as Lincoln's football captain for the upcoming 1925–1926 season. Skinny remained active and interested in sports. He learned to type with a special mouthpiece, and he typed 20 words per minute with an electric typewriter. Burt enjoyed entertaining celebrities and athletes at his home at 1680 South Fifty-Sixth Street. Burt died on December 3, 1966. (Courtesy of Marc Blau.)

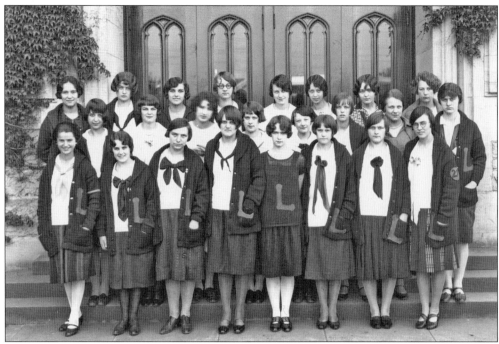

The 1925–1926 school year at Lincoln High School saw the formation of the Lincoln Letter Lassies, a new organization composed of 24 girls, each having earned one or more letters in athletics. The purpose of the group was to promote good sportsmanship and further interest in girls' athletics. (Courtesy of Tacoma Public Library.)

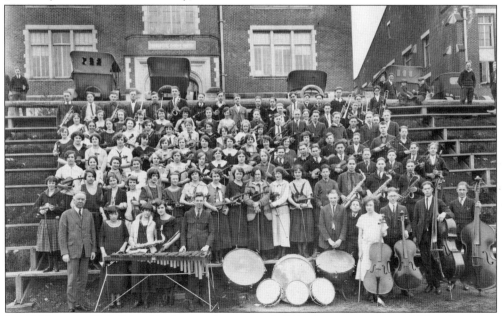

In 1924, Lincoln High School had two orchestras, with 62 in the senior group and 55 in the junior. They were led by David Nason (standing at left in first row). The orchestra played at assemblies, in concerts, and for several civic organizations. This photograph, taken on the Lincoln campus, was used in the 1924 school yearbook, the *Lincolnian*. (Courtesy of Tacoma Public Library.)

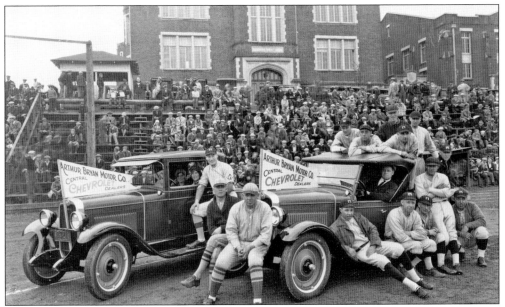

On April 21, 1928, the McKinley Hill Presidents baseball team, providing excellent advertising for the Arthur Bryant Motor Co. Chevrolet dealership, lounged on the two new Chevys parked inside the Lincoln Bowl. The Chevys were probably part of the parade of businesses that led the way to the Lincoln Bowl for the opening day of the 1928 Tacoma City League baseball season. (Courtesy of Tacoma Public Library.)

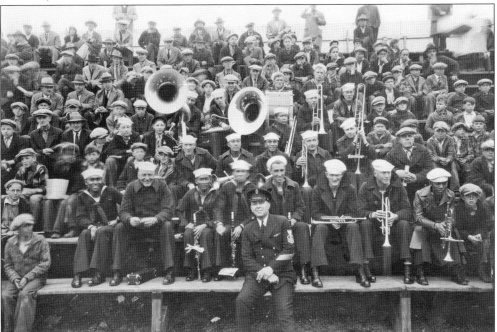

A US Navy band provided musical entertainment on opening day of the 1928 Tacoma City League baseball season in the Lincoln Bowl. The sailors got to watch an exciting match between the 1927 finalists, the Washington Co-ops and the McKinley Hill Presidents, a duel won by the 1927 champs, the Co-ops. (Courtesy of Tacoma Public Library.)

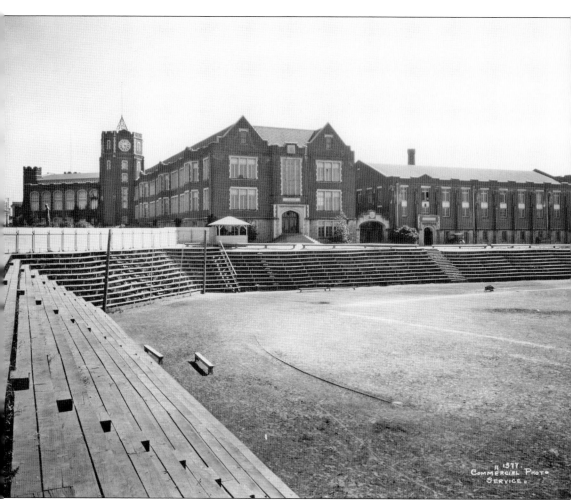

This picture from about 1925 provides an excellent view of the first Lincoln Bowl, a simple field with wooden bleachers that opened in 1920 directly north of the school and the Lincoln statue. The bowl provided a field not only for the high school's athletic activities but also for other community gatherings and sporting events. Plans would soon be in the works, however, for a much larger facility, closer in size to the Stadium Bowl than to the small field seen here. The project would require a public vote for the necessary funds and significant reshaping of the terrain of the gulch between the high school and the park. Construction was delayed for many years due to a lack of available labor during World War II, but the bowl finally came to fruition in the late 1940s. (Courtesy of Tacoma Public Library.)

Three

A COMMUNITY THRIVES IN CHALLENGING TIMES

The photographic record of the Lincoln District during the 1930s is a remarkable testament to the power of people sticking together in times of crisis. Although the working-class families and small-business owners of the area struggled through difficult economic times, the images in the coming chapter reveal stories of a community working hard to support one another, especially finding hope for the future in the classrooms of Lincoln High School.

Those classrooms were crowded during these years: Lincoln had the highest enrollment in Washington State during the 1930s, hitting a record of 2,585 students in 1934. In spite of this workload, individual teachers—especially one in journalism and one in music—built exceptional programs that inspired not only their students but also the entire community. It was not just students who gained new learning inside Lincoln's walls; the school had, since its opening, hosted night classes for adults, and these were filled to capacity during the Depression years.

Business owners formed the Thirty-Eighth Street Boosters Club and worked together to bring enough customers to the district to stay afloat. Local workers and businesses made contributions to support care for polio patients housed at the county hospital on Pacific Avenue. Crowds gathered at the Lincoln Bowl for everything from Unemployed Citizens League meetings to city league baseball games. In the 1930s, the community vision for a dramatically larger Lincoln Bowl came to the forefront. Progress on the project was stalled by a lack of available funds and then by a labor shortage during World War II, but the project was eventually completed in the 1940s.

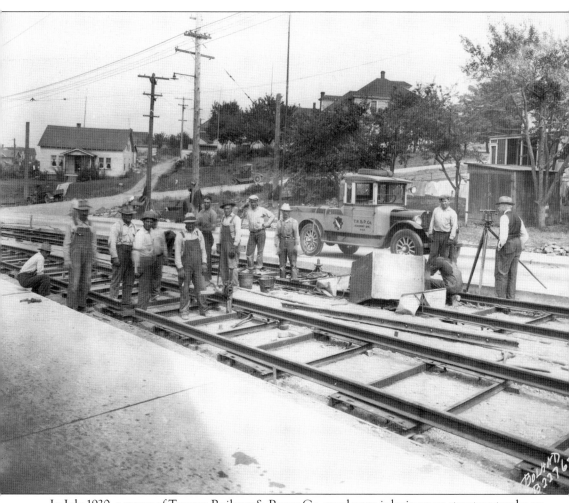

In July 1930, a group of Tacoma Railway & Power Co. employees is laying new streetcar tracks on Delin Street, just north of Holy Rosary Church between Tacoma Avenue and Fawcett Avenue. One of the workmen is crouched behind a metal shield labelled "danger." The man at the far right is standing behind a surveyor's level. The house at the left is believed to be 2909 Fawcett Avenue. Less than 10 years after this photograph was taken, Tacoma's streetcars were no longer running, and Tacoma was in the process of ripping out its tracks and selling the metal for scrap. At this date, however, this set of tracks was still a key means of transportation for those in the Lincoln District and communities to the south, such as Fern Hill and South Tacoma, to reach downtown Tacoma. (Courtesy of Tacoma Public Library.)

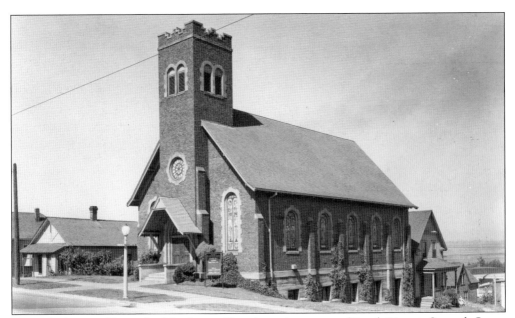

St. Paul's German Evangelical Lutheran Church, at the corner of South Twenty-Seventh Street and Tacoma Avenue, is featured in this 1930 image, which also includes a few of the neighboring homes. The congregation built its first church in 1894 one block south of this location, later demolishing that building when the church pictured here was built in 1910. (Courtesy of Tacoma Public Library.)

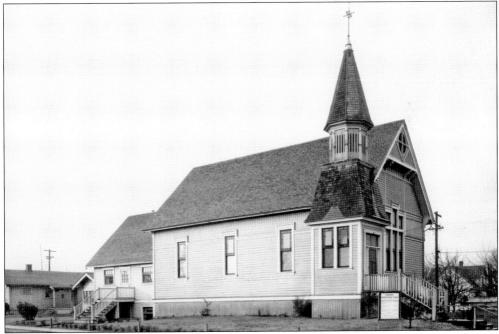

One of the oldest extant buildings in the Lincoln District is this church, which was built in 1886 a few blocks from its eventual location pictured here, South Thirty-Fifth and D Streets. This photograph is from around 1931, when the church was being utilized by the Calvary Presbyterian congregation. (Courtesy of Tacoma Public Library.)

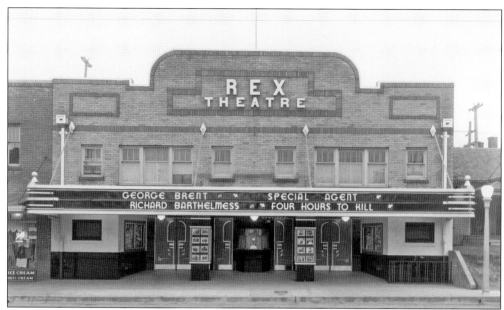

The Rex Theatre marquee advertised two films, *Special Agent* starring George Brent, and *Four Hours to Kill* featuring Richard Barthelmess, when this photograph was taken in 1935. The storefront to the north along Yakima Avenue advertises ice cream, and there is a house directly neighboring the theater to the south. (Courtesy of Tacoma Public Library.)

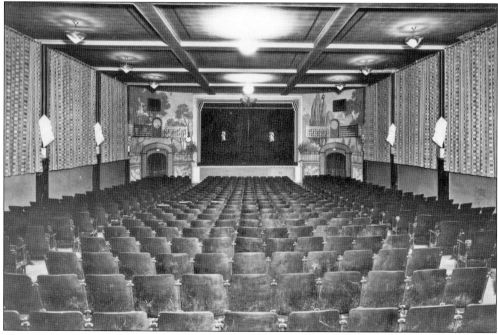

This photograph shows the interior of the Rex Theatre as it looked in 1936. The seats, many showing wear, likely date to the theater's original construction in 1919. Other design details, such as the trim around the stage and the dramatic light fixtures painted with dragons, reveal Art Deco influences and are therefore probably a more recent addition. (Courtesy of Tacoma Public Library.)

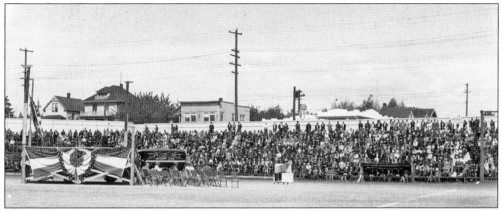

Tacoma photographer Chapin Bowen captured this image of an Unemployed Citizens League gathering at the Lincoln Bowl on May 29, 1932. The league facilitated cooperation, such as bartering and labor exchanges, as well as activism by unemployed adults during the Depression. Several homes and businesses along South G Street can be seen in the background. (Courtesy of Washington State Historical Society.)

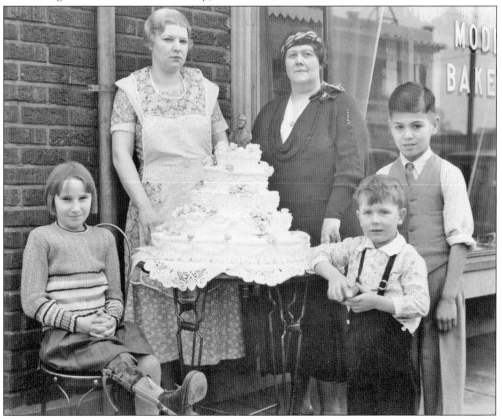

Two women and three small children, including one fitted with a leg brace, surround the multilayer decorated cake topped with a miniature bust of Pres. Franklin Delano Roosevelt in this c. 1935 photograph. The cake was from the Model Bakery, at the corner of South Thirty-Eighth Street and Yakima Avenue, as publicity for the President's Birthday Ball to benefit polio research. (Courtesy of Tacoma Public Library.)

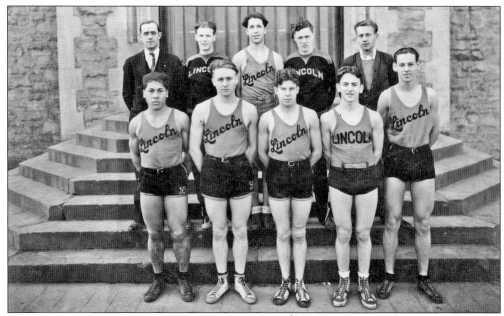

The 1932 Lincoln High School basketball team is photographed outside the school with coach Homer Post. In addition to his coaching responsibilities, Post was an extremely influential teacher, developing the *Lincoln News* into a nationally recognized student newspaper. During Post's tenure, the paper won dozens of national awards, and many of its alumni pursued careers in journalism. (Courtesy of Shanaman Sports Museum of Tacoma–Pierce County.)

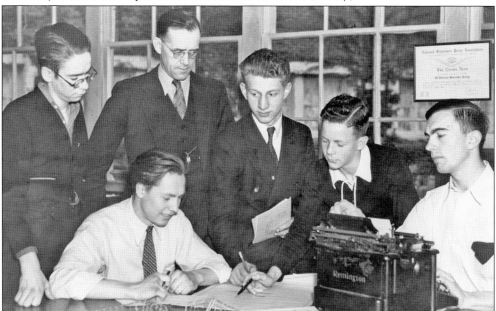

In April 1938, staff of the *Lincoln News* and faculty advisor Homer Post gather around a desk. The group has just received word that for the fifth time in six years, the paper had been given the Pacemaker All American award by the National Scholastic Press Association. Out of 967 entered publications, 218 were named All American, and only 10 were named Pacemakers. (Courtesy of Tacoma Public Library.)

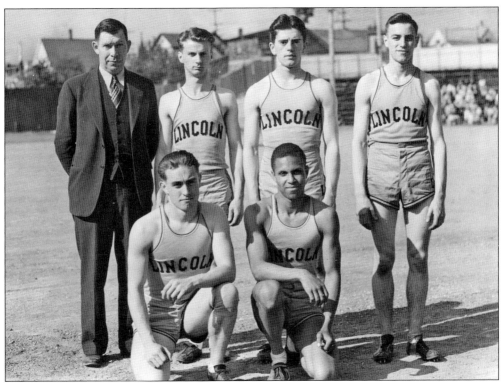

William Hardie, the Lincoln High School track coach, poses with five members of his team in September 1937. By the end of the year, the team had won the state track title for the third consecutive year. From left to right are (first row) Harold H. Berndt and Tommy Jones; (second row, last names only) Hardie, Rankin, Wilcox, and Sharp. (Courtesy of Tacoma Public Library.)

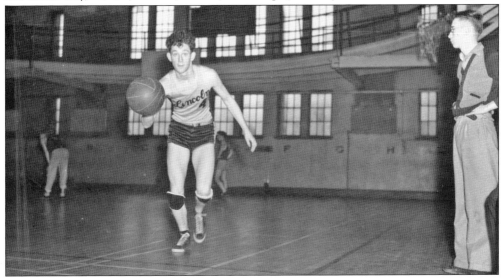

Lincoln High School forward Logan Blades, No. 4, dribbles a basketball down the Lincoln High School gymnasium court as he practices for an upcoming match against the Stadium Tigers in January 1939. Lincoln would go on to defeat Stadium on the north-end school's home court 29-22. Blades came off the bench to score eight points. (Courtesy of Tacoma Public Library.)

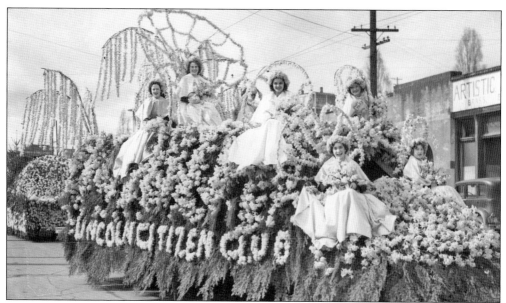

The six young women atop the Lincoln Citizens' Club float for the 1937 Daffodil Parade were all smiles as they prepared for the day's festivities. The float, adorned with 30,000 daffodils, went on to win honors in the annual parade event. The queen and her court were selected to represent the Lincoln Business District. (Courtesy of Tacoma Public Library.)

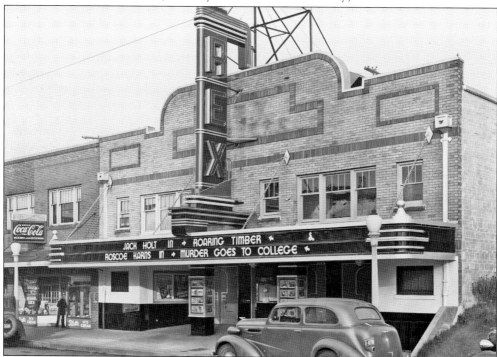

This photograph of the Rex Theatre from October 1937 shows the new marquee and neon sign built by the Cliff Sign Company. The faint outline of the previous signage can be seen on the brick behind the new sign. The shop next door appears to offer a full range of treats, including Coca-Cola, Flett's ice cream, and Brown & Haley's Almond Roca. (Courtesy of Tacoma Public Library.)

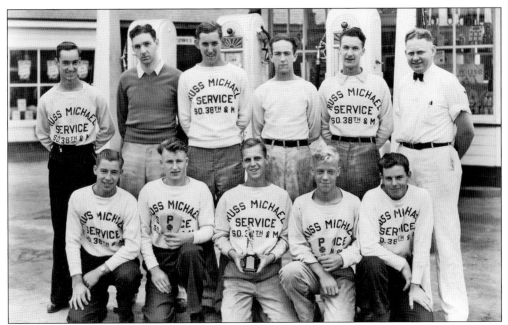

Russell H. "Russ" Michael (far right) poses in front of his service station at 3740 South M Street with the baseball team that he sponsored. The team had just won the Twilight League baseball championship for 1938. Russ Michael opened his station in 1936, and in the 1950s, he opened Michael's Oil Service at 1315 South Thirty-Eighth Street. (Courtesy of Tacoma Public Library.)

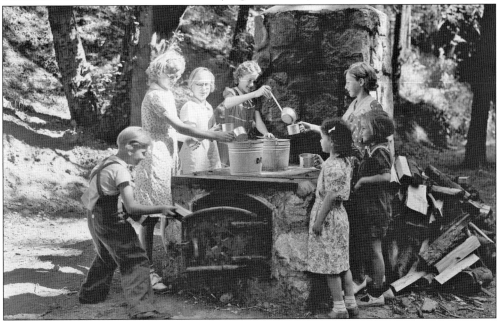

Girl Scout Day Camp, sponsored by the Tacoma Council, was held three days a week at Puget and Lincoln Parks during the summer of 1938. Here, Girl Scouts enjoy refreshments from the camp kitchen at Lincoln Park. The child in overalls is unidentified, but the others are, from left to right, Jean Coulter, Carol Betts, Dorothy Spence, Patricia Mozle, Jacqueline Baker, and Patricia Aitchison. (Courtesy of Tacoma Public Library.)

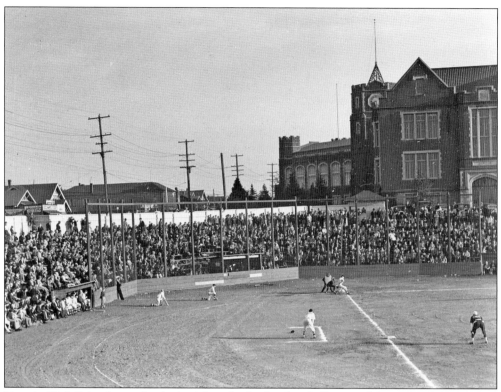

Lincoln High School provides the backdrop for the first baseball game of the Tacoma City League season on May 12, 1936. The bleachers are filled to capacity with fans watching the 1935 runner up, the Superior Dairy team, play the 1935 champs, the Beacon Oilers. The matchup marked the beginning of a 90-game season. (Courtesy of Tacoma Public Library.)

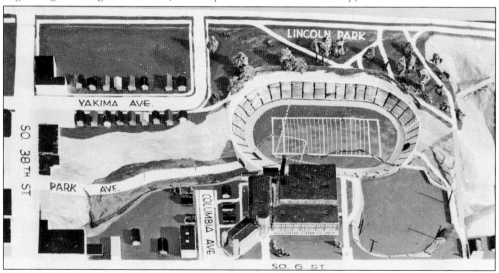

This model of the proposed Lincoln Bowl appeared in the *Tacoma Times* in September 1938. The bowl would seat 10,000 on concrete steps and cost about $250,000. Proponents were working to get it on the November 8 ballot, proposing that the district levy be increased by $1 million to raise the $50,000 needed to match $200,000 in federal grant funds. (Courtesy of Tacoma Public Library.)

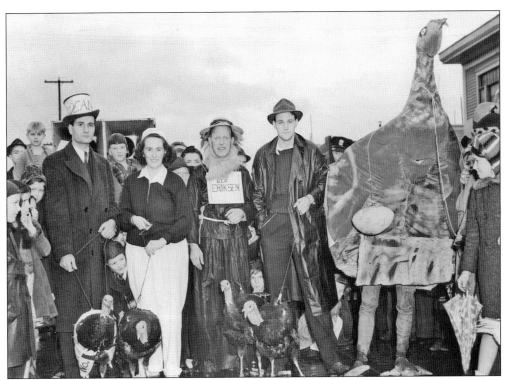

In order to stir interest in shopping, enthusiastic members of the newly formed Thirty-Eighth Street Boosters Club decided to sponsor a turkey derby on December 16, 1939. Thirty turkeys, spurred on by their jockeys, trotted down South Thirty-Eighth Street from G Street to Yakima Avenue. Each bird wore a sign identifying its sponsoring business and name. The turkeys were given away to lucky spectators. As newspaper coverage of the event pointed out, it was up to the new owners to determine exactly how to get them home. The novel promotional event attracted some 3,000 excited spectators and would be repeated annually into the mid-1940s. (Both, courtesy of Tacoma Public Library.)

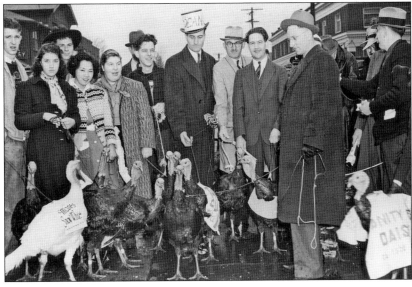

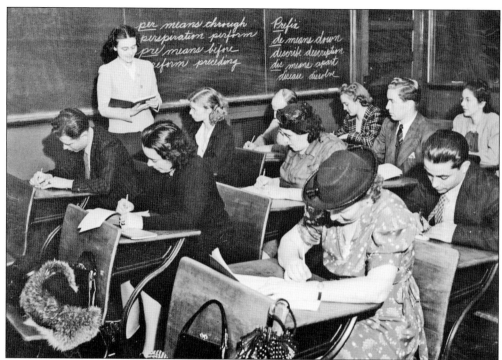

From its opening in 1914, Lincoln High School offered night classes intended for adults catching up on basic skills such as reading, writing, and math as well as new immigrants pursuing citizenship. In October 1939, when these two photographs were taken for an article in the *Tacoma Times*, more than 1,700 adults were attending 60 classes on Monday and Thursday nights. The most popular offerings were naturalization and Americanization, shop, and interior design. Lincoln's very popular night school was shut down when the United States entered World War II and did not restart after the war. (Both, courtesy of Tacoma Public Library.)

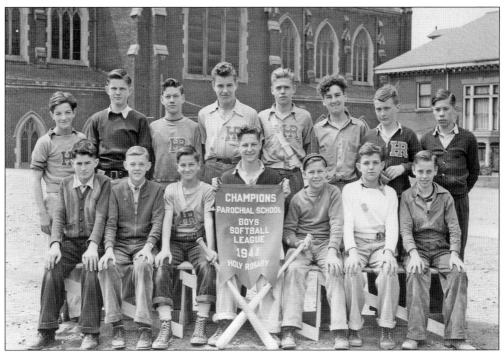

On May 27, 1941, the Holy Rosary softball team poses in front of its school at 502 South Thirtieth Street with a banner proclaiming the team to be the champions of the Parochial School Boys Softball League. The 1941 championship was the school's third over five years. (Courtesy of Tacoma Public Library.)

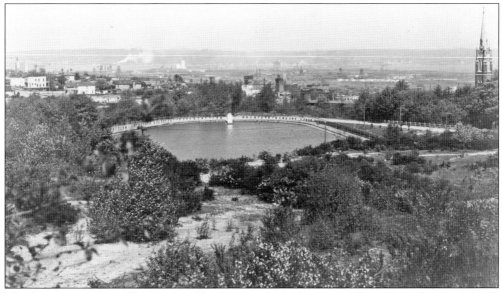

The distinctive spire of Holy Rosary Church is in the background at far right in this photograph of the Hood Street Reservoir from 1938. In the foreground, a few walking paths cut through what is otherwise undeveloped land south of the reservoir. In the distance from left to right are the early skyscrapers of downtown Tacoma, the Eleventh Street Bridge, and the tide flats. (Courtesy of Tacoma Public Library.)

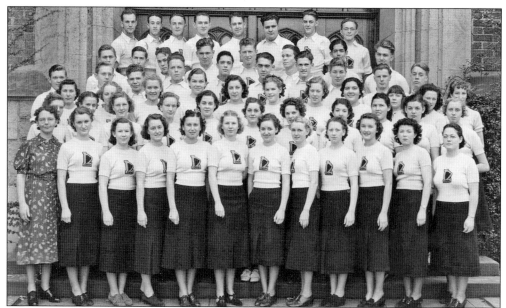

The Lincoln High School a cappella choir, pictured with director Margaret Rawson Goheen, was invited to participate in a national high school music competition in St. Louis in the spring of 1938. The event was not only a highlight in a long-successful music program at Lincoln, but it was also a dramatic train journey of 6,000 miles over 10 days for 60 students from working-class families, most of whom had never traveled outside of the Tacoma area. Hanging from the train was the banner seen below, which reads, "Lincoln High School 60 voices a cappella choir, extend greetings and good wishes from Tacoma Washington, America's evergreen playground." At each stop on the trip, the students shared not only their voices but also thousands of Puyallup Valley daffodils. (Both, courtesy of Tacoma Public Library.)

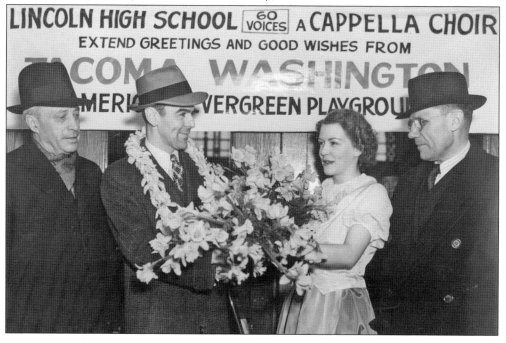

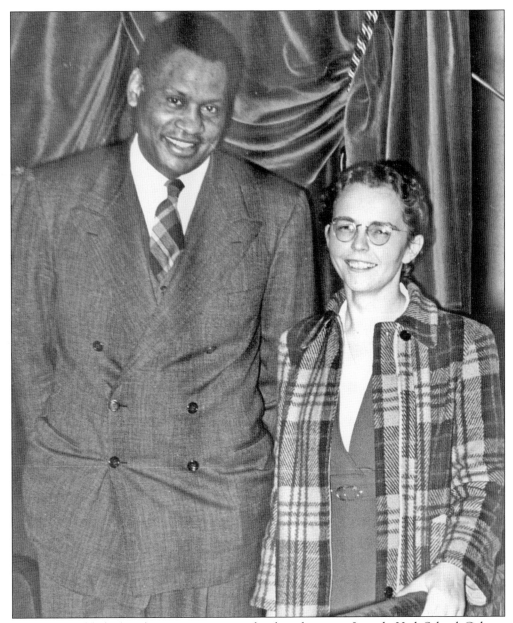

In another highlight from her 30-year career as the choir director at Lincoln High School, Goheen is pictured with Paul Robeson, who performed with the Lincoln choir during his first trip to Tacoma in a concert at the Temple Theater in November 1941. The concert program included *Ballad for Americans*, a patriotic cantata Robeson performed around the country during the World War II era. Although the multitalented baritone would typically have been accompanied by a professional choir, he chose to perform with the students from Lincoln. Decades later, choir alumni could still recall Goheen's intense rehearsals as well as the pride they felt when they had the opportunity to meet Robeson, who was generous in his praise of the quality of their work: "Among all the choirs who have helped with this piece, this is the easiest group with which I have ever sung. Those boys and girls and the conductor know what it's all about." (Courtesy of Tacoma Public Library.)

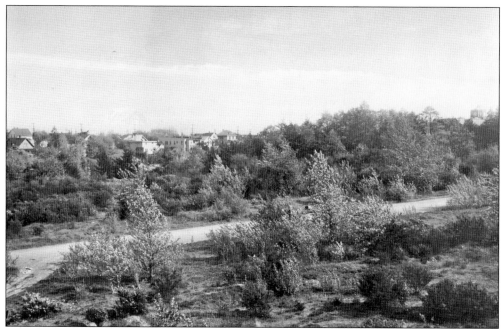

Lincoln's clock tower can be seen at far right and Mount Rainier is in the background at left in this image from about 1938, taken from vacant land between the high school and the Hood Street Reservoir. The houses at left are likely those along South G Street, north of the high school. (Courtesy of Tacoma Public Library.)

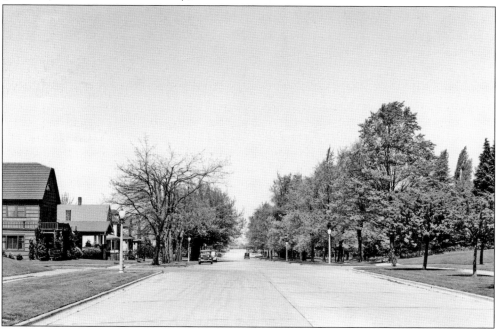

This wide street is South Thompson Avenue as it appeared around 1938. South Thirty-Eighth Street, a major artery through the Lincoln District, is just behind the photographer in this view looking north. Several houses can be seen along Thompson Avenue at left, and Lincoln Park is at right. (Courtesy of Tacoma Public Library.)

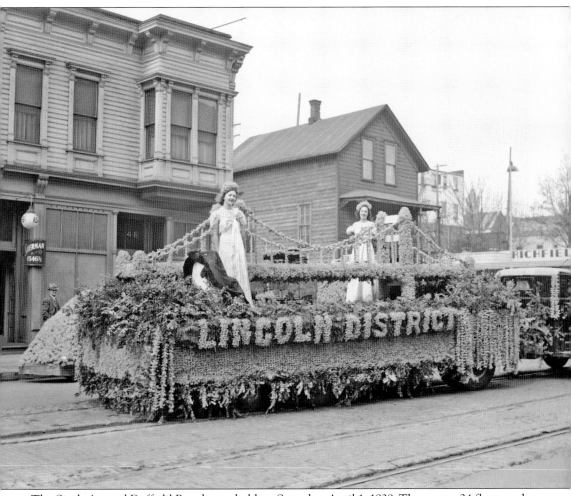

The Sixth Annual Daffodil Parade was held on Saturday, April 1, 1939. There were 24 floats and 13 marching bands. The parade stretched for almost two miles and took 40 minutes to pass. In this photograph, the float built by the Lincoln Citizens' Club, representing the Lincoln District, passes the Sherman Hotel at 1546 Broadway. The two smiling young women on the float are both wearing crowns made of daffodils. With its daffodil model of the first Tacoma Narrows Bridge, this float placed second in the organizations category. At the time of this parade, the first Tacoma Narrows Bridge was under construction but not yet open, and its fate as "Galloping Gertie" was as yet unknown. In the spring of 1939, it was logical for the Lincoln Citizens' Club to celebrate the engineering marvel currently under construction in Tacoma. (Courtesy of Tacoma Public Library.)

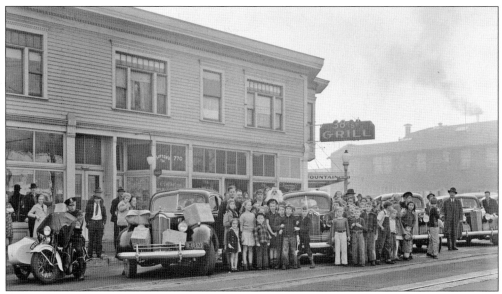

Santa Claus alights from his Packard automobile to greet children at the intersection of South Thirty-Eighth Street and Yakima Avenue during his journey from the Mueller Harkins Airport to the Peoples Store in downtown Tacoma on November 24, 1939. This was one of five scheduled stops where children could meet Santa, who distributed candy and small gifts. (Courtesy of Tacoma Public Library.)

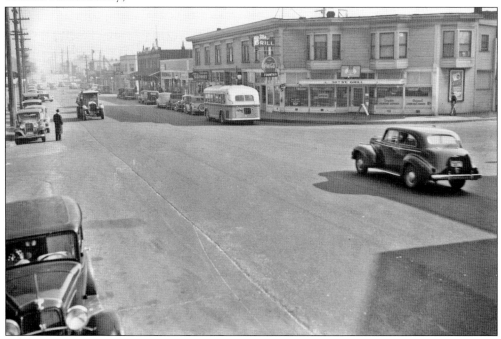

This photograph of the intersection of South Thirty-Eighth Street and Yakima Avenue looking east was taken in February 1941 to show the completed paving of Thirty-Eighth Street after the removal of streetcar tracks. The Thirty-Eighth Street Grill anchors the corner building at right, which is also home to Lincoln Sea Foods. Thirty-Eighth Street is busy with car, bus, and pedestrian traffic. (Courtesy of Tacoma Public Library.)

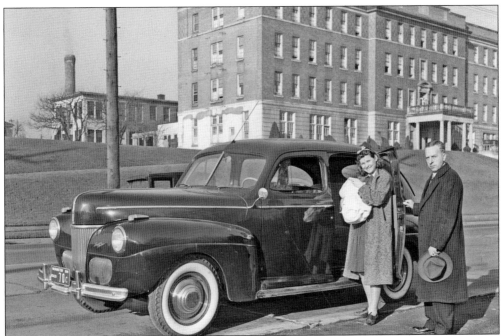

The winner of the 1941 Tacoma News Tribune Stork Derby (for the first baby of the year) was a nine-pound, three-ounce baby boy born to Edna and Herbert Parham at 12:08 a.m. on January 1, 1941. One of the prizes was a ride home in a 1941 Super DeLuxe Ford from the Pierce County Hospital, in the 3500 block of Pacific Avenue. (Courtesy of Tacoma Public Library.)

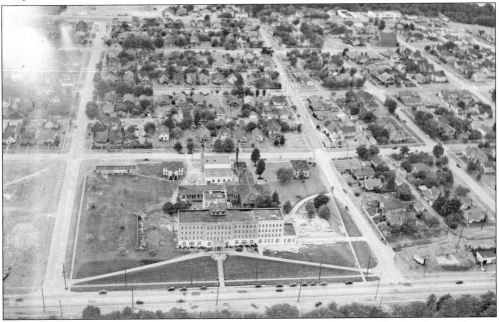

This aerial view of the Pierce County Hospital and its surrounding neighborhood was taken in July 1941. The hospital's new north and west wings are nearing completion. At the upper left corner is the excavation for the Lincoln Bowl, which would not be completed until after World War II. (Courtesy of Tacoma Public Library.)

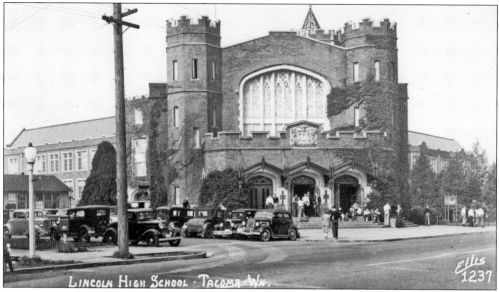

Lincoln High School is busy with students and vehicles in this photograph from 1940, which can be dated by the "Dill for Governor" banner on one of the cars parked outside the school's auditorium. Clarence Cleveland Dill served two terms each in both houses of Congress and was narrowly defeated in the 1940 election for governor of Washington State. (Courtesy of Tacoma Historical Society.)

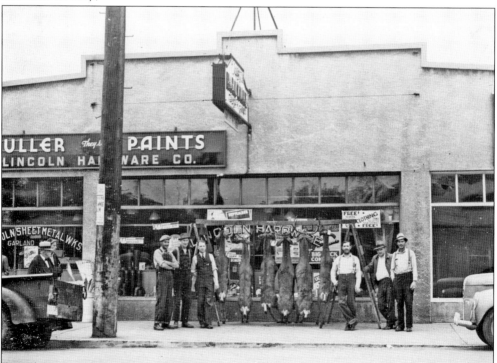

A group of men poses outside the Lincoln Hardware Company on South G Street with the results of a hunt in 1940. Third from left, in vest and tie, is J.B. Feist, who would build a new store for Lincoln Hardware on this same block in 1946. (Courtesy of Jennifer Feist.)

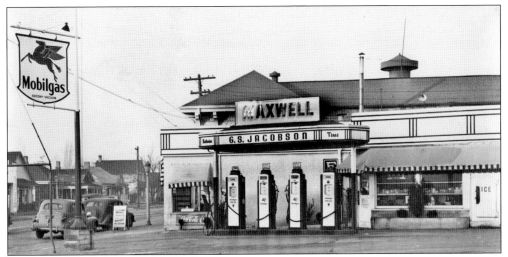

G.S. Jacobson's Maxwell service station, at the corner of South Fifty-Sixth and M Streets, is photographed around 1942. In addition to selling Mobilgas, with the distinctive Pegasus logo, the station advertised tires, batteries, brake and wheel alignment, and headlight testing. Goodwin S. Jacobson lived with his wife, Nellie, at 4323 South L Street. (Courtesy of Tacoma Public Library.)

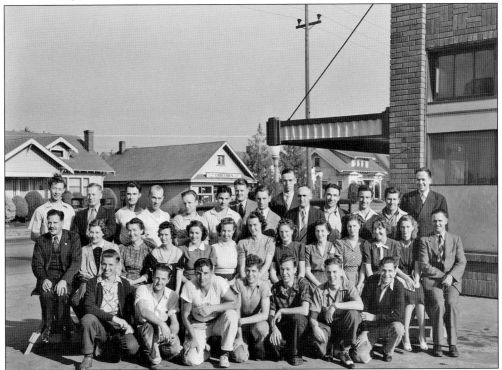

In 1940, the staff of Miller & Miller Co. poses on the side of their office building, 4006 Pacific Avenue. Miller & Miller were commercial printers who designed and printed labels as well as banners and counter and window displays. They moved into this former Piggly-Wiggly building in 1938. Across Pacific Avenue are several homes and a small grocery store. (Courtesy of Tacoma Public Library.)

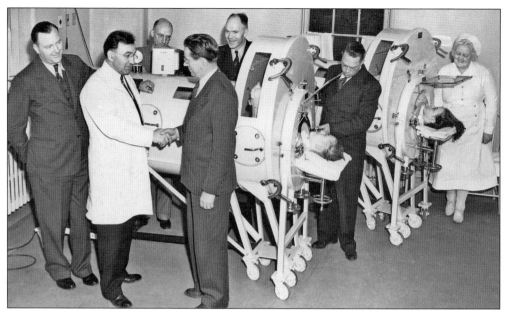

The Tacoma District Council of the Lumber & Sawmill Workers Union (AFL), made up of 13 local unions, presents two modern iron lungs to the Pierce County Hospital on January 21, 1941. The iron lungs were needed to help patients struck down by polio. Each machine cost $2,000, which was raised by a $1 donation from each union member. (Courtesy of Tacoma Public Library.)

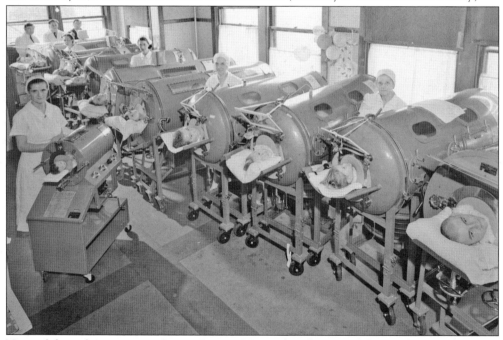

Nine of the polio patients at Pierce County Hospital and seven of the ward's staff pose for a *Tacoma Times* photographer in September 1940. The patients and staff are celebrating the third birthday of Katherine Ann Clinton of Midland (not pictured), who had recovered enough from her infection that she only required part-time treatment in a respirator. (Courtesy of Tacoma Public Library.)

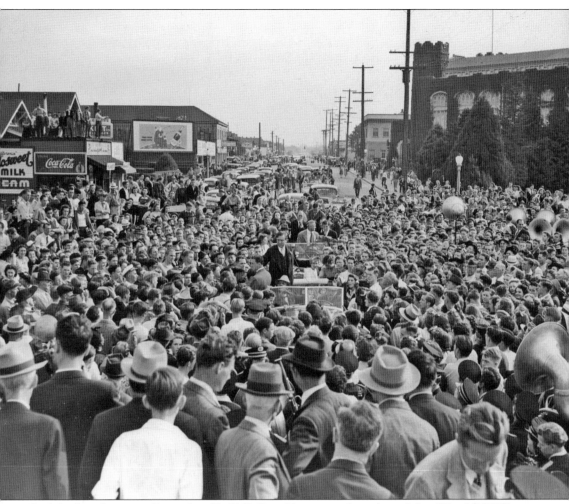

On Monday afternoon, September 23, 1940, Republican presidential candidate Wendell Willkie addressed a crowd of several hundred from an open automobile in front of Lincoln High School. Willkie and his entourage, on the train dubbed the "Willkie Special," had pulled into the Northern Pacific Railroad shops a short time before during a planned one-hour visit to Tacoma. Lincoln High School was one of just four stops Willkie made while in Tacoma; the tubas and horns of the Lincoln band greeted him as well as the Pacific Lutheran College chorus. South G Street is packed with supporters of Willkie and curious onlookers. Several adventurous Lincoln students have sought out an even better view from the roof of the Bee Hive, a soda fountain directly across G Street from Lincoln. Willkie was the first Republican candidate for president to visit Washington State in 24 years. He lost the election to Franklin D. Roosevelt by a wide margin. (Courtesy of Tacoma Public Library.)

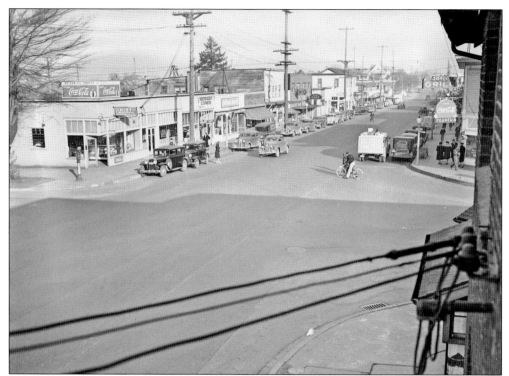

This view of South Thirty-Eighth Street near Yakima Avenue in February 1941 shows the newly completed paving of the busy roadway, with businesses ranging from restaurants to clothing stores in view. There were apparently no traffic lights or crosswalks at intersections along this stretch of Thirty-Eighth Street at this date, as pedestrians and bicyclists can be seen waiting to cross the street. (Courtesy of Tacoma Public Library.)

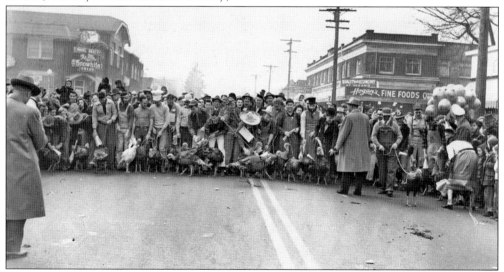

Another iteration of the Thirty-Eighth Street Boosters' Club turkey derby appears ready to start, with numerous men attempting to keep their turkeys in order at the intersection of South Thirty-Eighth Street and Yakima Avenue in this photograph from the early 1940s. In the background at left is the Model Bakery, and at right is Hogan's Fine Foods. (Courtesy of Jennifer Feist.)

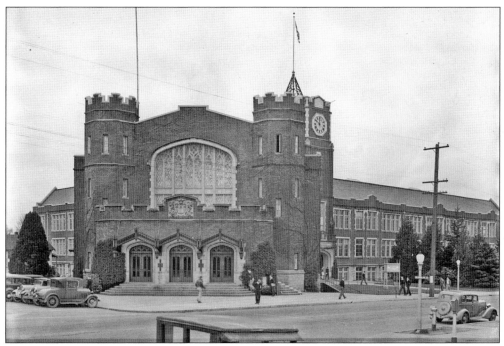

Lincoln High School's familiar turreted auditorium and clock tower are on full display in this photograph from February 1940. At this date, the street along which many cars are parked was still known as Columbia Avenue, and it still came to a dead-end at the gulch behind the school, just out of view in this photograph. (Courtesy of Tacoma Public Library.)

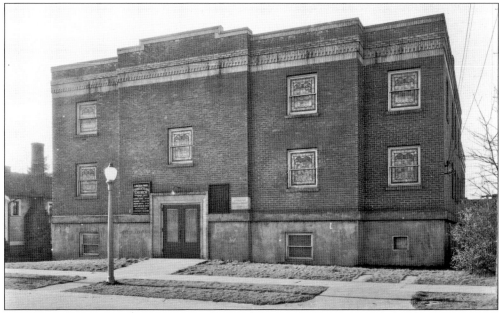

Lincoln Park Christian Church, pictured here likely in the 1940s, was completed in 1920 at 3834 South G Street. Prior to the construction of this building, the congregation held services and Sunday school at Pallies Hall, on the corner of South Thirty-Eighth Street and Yakima Avenue. (Courtesy of Tacoma Public Library.)

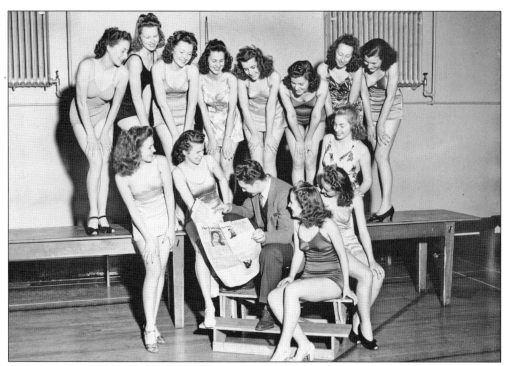

In the spring 1941, Lincoln High School music teacher Margaret Rawson Goheen gave her blessing for a group of ambitious students to write and produce an original musical, *Of Men and Models*, which would take the place of the usual spring operetta. The students, led by LeRoy "Lee" Hale, developed the story—about a football hero who inherited a Fifth Avenue dress shop—and wrote all-original music and lyrics for the show. Pictured above are many Lincoln High School girls in bathing suits and high heels hoping to be cast in the show by an unidentified male student, and below is the all-cast photograph. (Both, courtesy of Tacoma Public Library.)

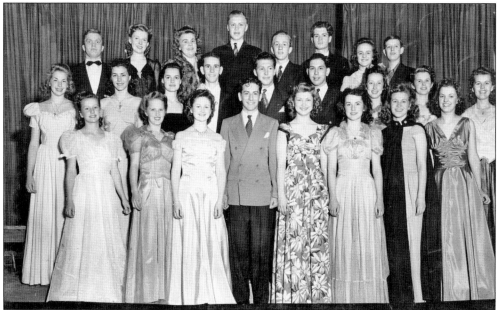

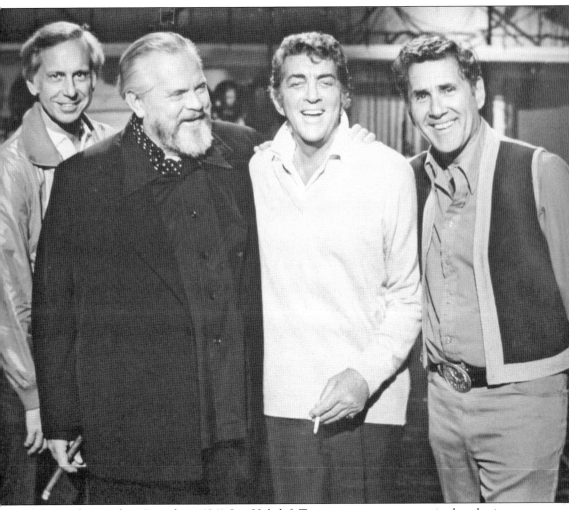

After graduating from Lincoln in 1941, Lee Hale left Tacoma to pursue a career in show business, enjoying a diverse range of successes on stage and especially in television. Following his service in the Navy and work as a music arranger and performer for a number of traveling shows, he was the music director for *The Dean Martin Show*, a television variety show that ran from 1965 to 1974. In that role, he frequently appeared on camera in comedic and musical numbers but more importantly worked with each of Martin's wide range of guests to make sure they were prepared for their musical performances on the show, writing original arrangements and standing in for Martin during rehearsals. This photograph of, from left to right, Lee Hale, Orson Welles, Dean Martin, and Greg Garrison was taken in 1977 following a "Best of Dean Martin" show. (Courtesy of Lee Hale.)

During World War II, although the races fought side by side, the Army was still segregated. African American servicemen had their own USO club in Tacoma, the USO No. 2 at 713–715 Commerce Street. For Mother's Day, 1943, the Tacoma community tried to make the men feel at home by inviting them to a special church service. The Lincoln High School a cappella choir provided musical entertainment for the occasion. In addition to their frequent concerts in the Lincoln auditorium and their success in competitions and music festivals around the region, the Lincoln choirs under the direction of Margaret Rawson Goheen also performed a great deal of musical service, especially during the war years. She brought her singers to both of Tacoma's segregated USO clubs, as well as to the military hospitals at Fort Lewis and McChord Air Force Base, where individual students sang to recuperating soldiers. (Courtesy of Tacoma Public Library.)

The exact date of this photograph is unknown, but it is likely from the early 1940s, when excitement over the construction of the Lincoln Bowl was still heightened in spite of the project's delays during the war years due to a lack of available workers. This Daffodil Parade float features a Lincoln Bowl made entirely of daffodils. (Courtesy of Tacoma Public Library.)

On May 19, 1943, Joe Holmquist outshot a field of eight district marble champions to become the Tacoma grade school marble champion. Joe, a student at Edison school, won the crown and a $25 war bond. The competition was held in the Lincoln Bowl, which was in the midst of construction at this date. (Courtesy of Tacoma Public Library.)

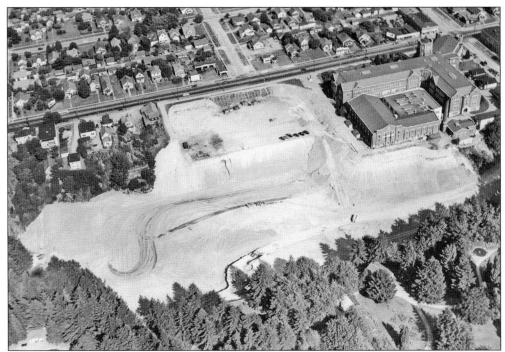

By July 1941, real progress was finally being made on the new athletic amphitheater being built to the northwest of Lincoln High School, some 10 years after civic groups in the south end of Tacoma started campaigning for a bowl to rival the Stadium Bowl next to Stadium High School. (Courtesy of Tacoma Public Library.)

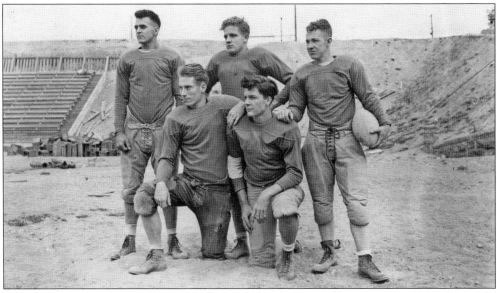

In September 1942, five members of the Lincoln Abes varsity 11 pose in the unfinished Lincoln Bowl prior to their opening game against Stadium High School. Pictured are, from left to right, (first row) Ingwald Thompson and Gordon Brunswick; (second row) Ed Bemis, LeRoy Turnbull, and an unidentified player. The team finished the season by winning the city championship for the first time in nine years. (Courtesy of Tacoma Public Library.)

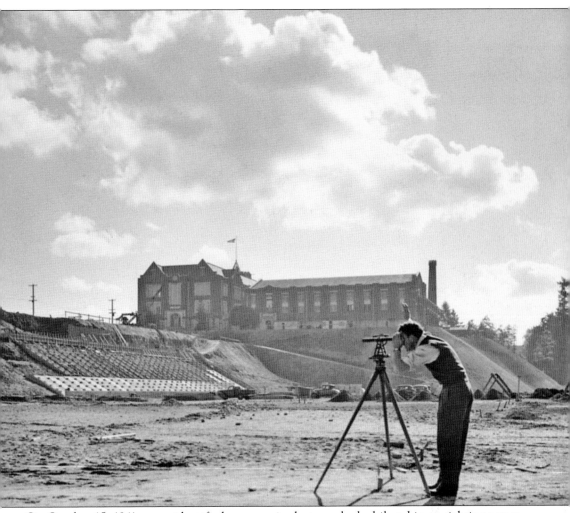

On October 15, 1941, an unidentified surveyor is photographed while taking a sighting across the unfinished bowl at Lincoln High School. The school can be seen in the background. Under the headline "It Won't Be Long Now, Men," this photograph ran in the sports section of the *Tacoma Times* two weeks later on October 30. The Lincoln Bowl was not officially dedicated until September 24, 1948, seven years after construction began. World War II stopped virtually all work on the project, and a lack of funds plagued further construction after the war. Once complete, the Lincoln Bowl would allow several thousand spectators to be seated in concrete stands on the east and west sides of the field, providing the school and the city as a whole with an important venue for sports, concerts, and community gatherings. (Courtesy of Tacoma Public Library.)

Streetcar tracks are being removed on Center Street and Tacoma Avenue in February 1941. Tacoma Railway & Power was granted a four-year contract to remove the now-obsolete rails, some 75 to 80 miles of them, but the city decided the company was moving too slowly and took over the process itself. (Courtesy of Tacoma Public Library.)

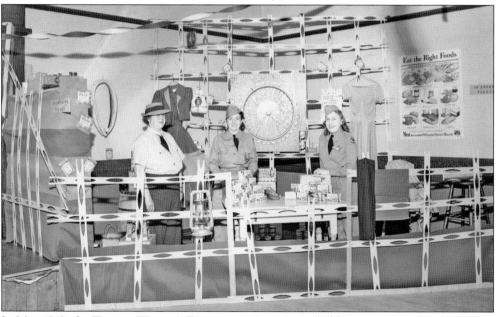

In May 1942, the Tacoma Women's Emergency Motor Corps held a carnival in Horsfall Hall at 801–809 South Thirty-Eighth Street to raise money to help the corps carry on its work. The women of the corps were trained to drive and maintain Tacoma's emergency vehicles. The carnival included bingo, card games, a fortune teller, and various food and game booths. (Courtesy of Tacoma Public Library.)

Four

FINISHING THE BOWL AND THE FIFTIES BOOM

Building on a strong foundation, the Lincoln District was poised for growth in the booming postwar economy. Many of the images in this chapter center around construction projects big and small. Several of these projects marked the growth of existing businesses or the arrival of new ones: Lincoln Bowling Alleys was built in 1945, followed soon after by a new Lincoln Hardware building 1947 and a new Lincoln branch of Puget Sound National Bank in 1951, just to name a few. The single most expensive building project in Pierce County up to that time, Mountain View Sanatorium, a tuberculosis care facility, opened in 1952 adjacent to the existing Pierce County Hospital on Pacific Avenue.

The completion of the new Lincoln Bowl in 1948, however, brought the most community excitement. With tiered concrete seating for 10,000, the facility was intended as far more than just a high school sports stadium. The Stadium Bowl had been witness to countless large gatherings over the previous decades, from concerts to parades to fireworks shows, and the Lincoln Bowl could provide this same community gathering venue for its own neighborhood. As the photographs shared here document, the bowl would live up to its billing. One of the more famous visitors to the Lincoln Bowl—Elvis Presley, who played a matinee show on September 1, 1957—is not even included here to make more room for other examples with which readers may be less familiar.

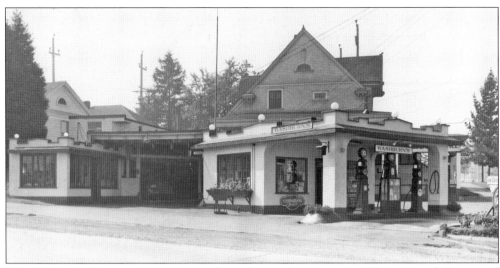

This Mission-style service station was built on the southwest corner of Thirty-Fourth Street and Pacific Avenue in 1924 by William F. Washburn. He and his wife, Genevieve, lived just around the corner from the station at 224 South Thirty-Fourth Street in a home they purchased around 1920. This photograph was taken in September 1945. (Courtesy of Tacoma Public Library.)

Lincoln Hardware owner J.B. Feist is in the process of setting out merchandise in his new store at 3726 South G Street in May 1947 just prior to its grand opening. The business had previously operated in an older building on the same block before Feist built the new storefront in 1946. (Courtesy of Jennifer Feist.)

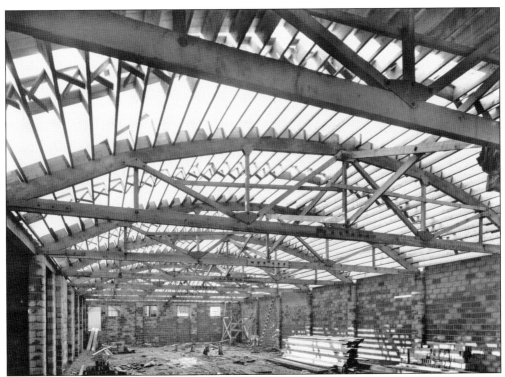

William D. Smith and Clyde E. Murray were the consulting engineers during the construction of the Lincoln Bowling Alleys building at 3828 Yakima Avenue South in November 1945. Laminated beams that spanned the width of the building were used to create the curved roof line. When completed, Lincoln Bowling boasted eight Brunswick alleys with a floodlighting system that guaranteed shadowless lighting. The building was entirely air-conditioned. Mayor Harry P. Cain was master of ceremonies for the formal opening on Saturday, February 15, 1946, and invited 16 of the city's top bowlers to "start the balls rolling." Stanford B. Hodgman operated the business from its opening until 1955. The building was demolished in 2012. (Both, courtesy of Tacoma Public Library.)

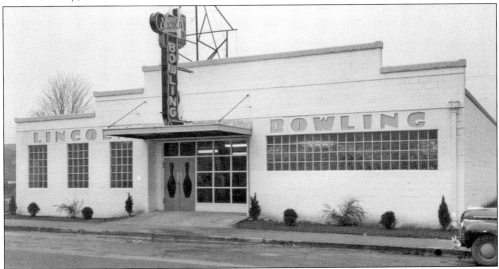

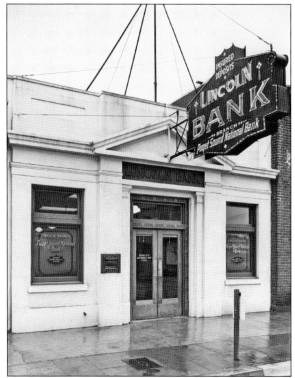

Lincoln State Bank opened in this building at 3808 Yakima Avenue South in November 1925. The bank failed in 1931, and in 1935, Puget Sound National Bank, which had been operating in Tacoma since 1895, reopened this building as its second branch. Aside from the large neon sign added to the exterior, the building did not change significantly with the transfer of ownership. Puget Sound National Bank advertised that it had the most competent, well-trained people and specialists in every area of money management. On October 10, 1947, staff at the Lincoln branch pose inside their bank, with its terrazzo floors and service windows trimmed in dark wood and marble. (Both, courtesy of Tacoma Public Library.)

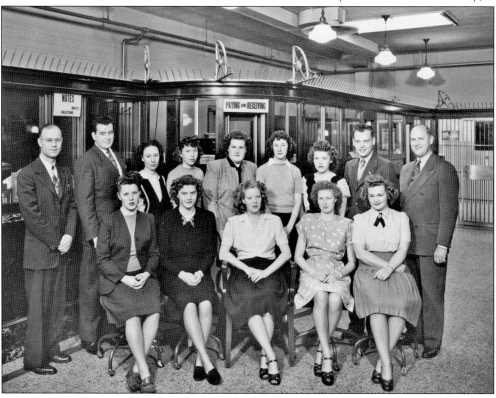

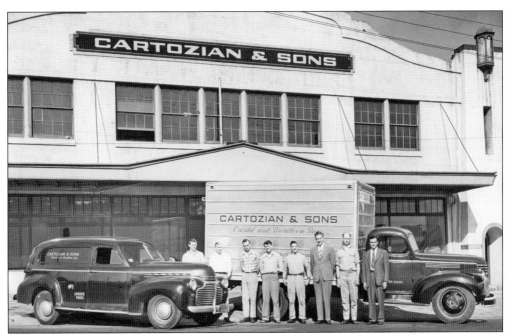

In July 1947, Edward S. Cartozian moved his carpet business in Tacoma from 759 Broadway to the old automobile dealership building at 3320 South G Street. The Cartozian family had been in the carpet business in the Pacific Northwest since 1906, when Abram O. Cartozian started selling Oriental rugs from a small rented room in Portland. (Courtesy of Tacoma Public Library.)

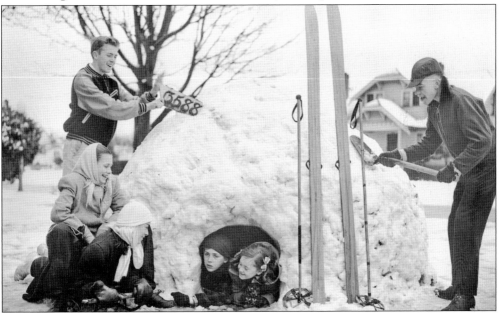

In February 1948, a group of neighbors enjoys playing in the snow in the 3500 block of Tacoma Avenue South. Standing at left and placing an address on the snow fort is Jerry Kennedy. At right, Hubert Weber has taken up a shovel in exchange for his cross-country skis. The other children, from left to right, are Ann Weber, Marlene Kennedy, Donald Kennedy, and Marilyn Murphy. (Courtesy of Tacoma Public Library.)

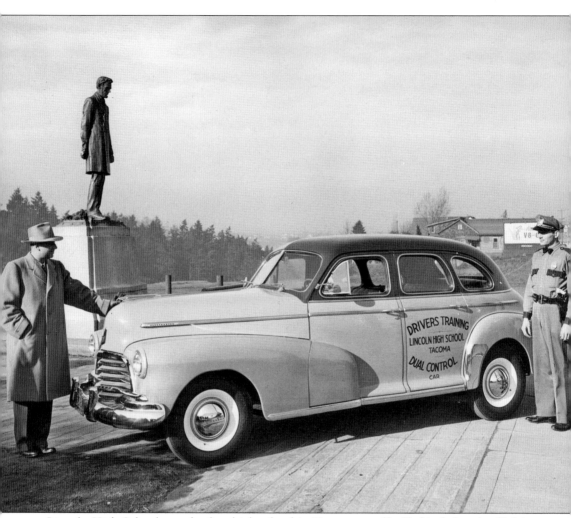

Lincoln High School was the first high school in Tacoma to offer "behind the wheel" driver training. In February 1947, a new Chevrolet with dual controls was donated to Lincoln High School by South Tacoma Motor Company so that the new one-credit course could begin. Stadium High School began offering a similar course the following fall. The statue of Abraham Lincoln appears to be looking down on C.W. Wallerich (left), the treasurer for South Tacoma Motor Company, and Sgt. George Amans of the Washington State Patrol as the vehicle is delivered to the school. (Courtesy of Tacoma Public Library.)

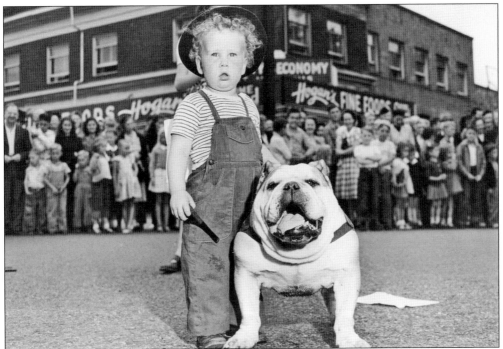

A curly haired young boy wearing a striped shirt, overalls, and a hat poses with a bulldog. The boy and his dog were entrants in the Pet Parade, held in the Lincoln business district on Saturday, July 26, 1947. A large crowd stands behind the boy and his dog in front of Hogan's Fine Foods Store at the corner of South Thirty-Eighth Street and Yakima Avenue. (Courtesy of Tacoma Public Library.)

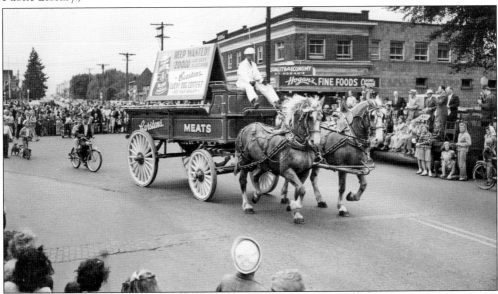

The 1947 Pet Parade started at Lincoln Park and proceeded through the business district. Awards were presented to contestants by businesspeople of the Lincoln shopping district, with free ice cream and balloons for all. Here, a wagon pulled by two matched horses advertises Carstens Meats and its Lucky Dog-Dog Food Contest. (Courtesy of Tacoma Public Library.)

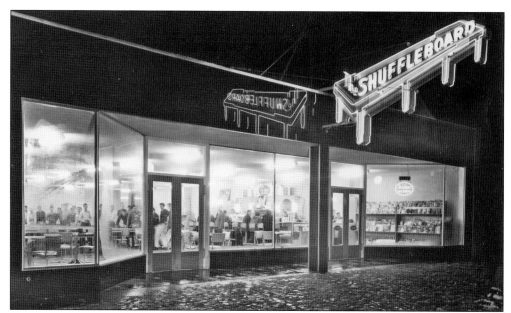

When it opened in 1948 at 3805 South G Street, the Shuffleboard was advertised as Tacoma's newest family restaurant and the only place in the Northwest offering shuffleboard to the general public, with no alcoholic beverages served. The restaurant boasted a birch-wood snack bar featuring refreshments, soft drinks, ice creams, and other confections. Shuffleboard instructors were on hand, customers were invited to join leagues, and prizes were awarded every night. The interior photograph was captured just before the grand opening. The exterior photograph, with many patrons inside on what appears to be a cold night with slush on the sidewalk outside, was taken on the first night of business, December 10, 1948. (Both, courtesy of Tacoma Public Library.)

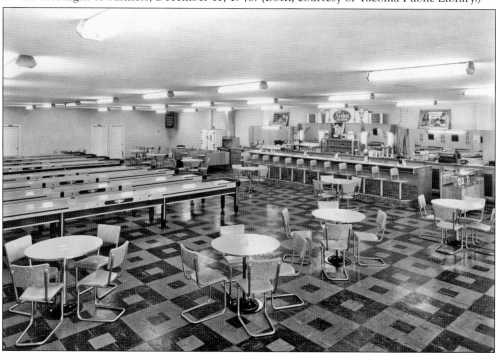

Lincoln Bowling Alleys, at 3828 Yakima Avenue South and owned by Stanford B. Hodgman, sponsored the Lincoln Ladies League Bowling Championship in January 1949. One of the teams in contention was the Tacoma 600 Club, pictured here. The last names of the women are not known, but their shirts are embroidered with first names: (from left to right) Carmen, Dot, Aggie, Ruth, and Babs. (Courtesy of Tacoma Public Library.)

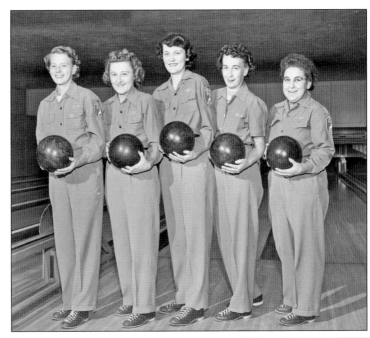

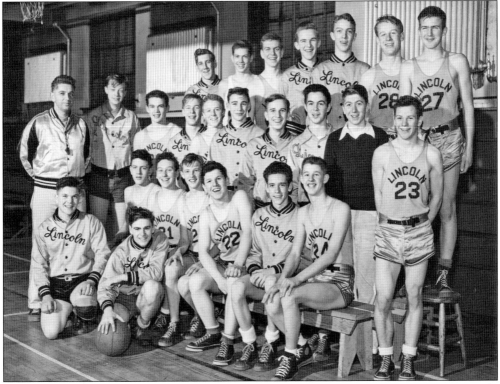

This enthusiastic group is the 1948 Lincoln High School sophomore basketball team, the Lincoln Golds. Coach John Pyfer is standing on the left wearing a jacket and whistle. This photograph was taken in the Lincoln gymnasium on January 21, 1948, for an article about the team in the *Tacoma Times*. (Courtesy of Tacoma Public Library.)

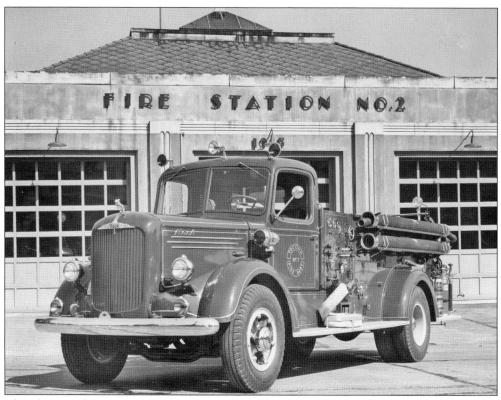

This photograph was taken in 1947, shortly after the Tacoma Fire Department bought three new fire trucks from Tacoma Truck and Tractor Company, including this Mack pumper truck for Fire Station No. 2. The station had been significantly remodeled in 1935, transforming the 1907 brick building into a sleek Art Deco design capable of handling more modern equipment. (Courtesy of Tacoma Public Library.)

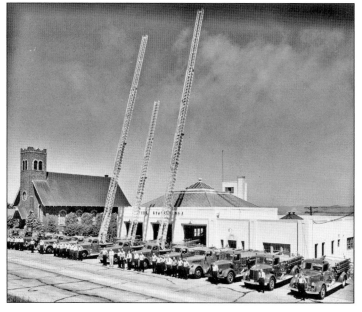

In 1944, the Tacoma Fire Department began an extensive modernization program aimed at upgrading its aging fleet. This picture, taken in June 1948, shows the department's impressive collection of trucks lined up along Tacoma Avenue South in front of Station No. 2. The fleet includes three Peter Pirsch 1,250-gallon-per-minute pumpers with all-steel aerial ladders. St. Paul's Evangelical Lutheran Church is at left. (Courtesy of Tacoma Public Library.)

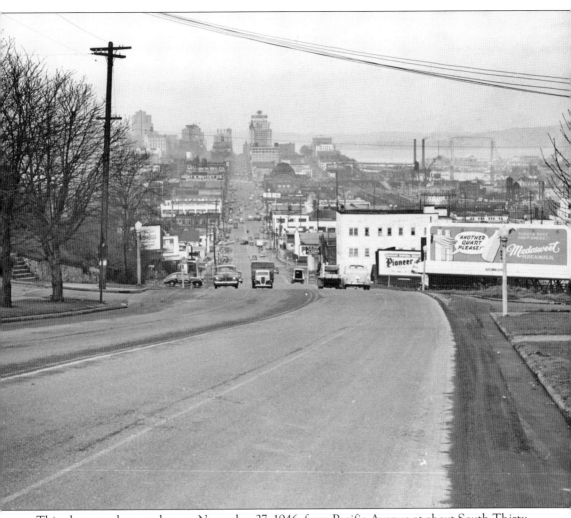

This photograph was taken on November 27, 1946, from Pacific Avenue at about South Thirty-Second Street looking north into downtown. Much about this view remains familiar to those residing in the Lincoln District today, with Pacific Avenue still providing a fast connection to the downtown core. The downward grade of this stretch of Pacific Avenue is not yet as severe as it would later be, when it would become a bridge over Interstate 5. Billboards on the right advertise Medosweet Milk and Pioneer Beer. Commencement Bay is seen above the tide flats. Union Station is the domed building on the right side of Pacific Avenue, while painted signs identify the Hunt & Mottet Hardware Company and F.S. Harmon Manufacturing Company on the left side of the wide street. At left in the distance is the Medical Arts Building, which joined the Tacoma skyline in 1930. (Courtesy of Tacoma Public Library.)

After extensive delays during and immediately following World War II, work on the Lincoln Bowl project was finally underway again in 1947. Here, on October 2, workers from C.S. Barlow & Sons, a longstanding Tacoma company, pour concrete into forms that will create the foundation for the tiered seating on the west side of the bowl. Lincoln High School sits atop what now seems a steep hill southeast of the bowl, providing some sense of the amount of earth that was removed to shape the project. Construction offices and workers' cars can be seen at the south end of the bowl as it meets the tall trees of Lincoln Park. In the distance behind the workers, Lincoln students are involved in some kind of athletic practice on the dirt floor of the bowl. (Courtesy of Tacoma Historical Society.)

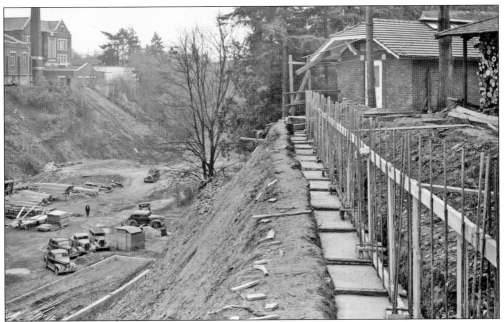

This photograph from November 19, 1947, documents the first steps in the creation of a fence that will separate Lincoln Park, at right, from the tiered seating on the west side of the Lincoln Bowl. The high school can be seen at far left, and at right is a park restroom and covered pile of wood for use in the park stoves. (Courtesy of Tacoma Historical Society.)

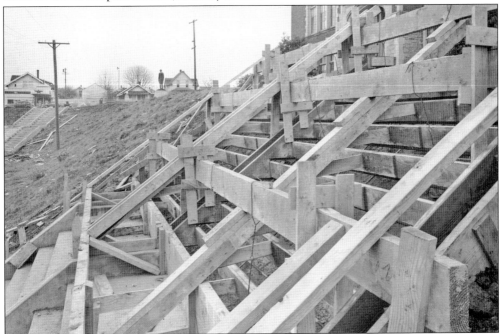

Concrete seating at the south end of the bowl is in various stages of completion in November 1947. This photograph also shows, from left to right, a service station on South G Street, the rear of the Lincoln statue, and a north entrance to Lincoln High School, with the word "justice" in stone above the doors. (Courtesy of Tacoma Historical Society.)

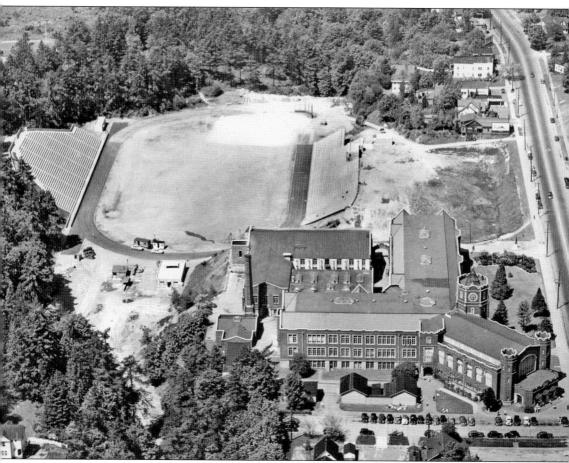

By June 2, 1948, when this aerial photograph was taken to document progress on the Lincoln Bowl project, the concrete seating on the west side was complete, but additional work was still underway on the south and east sides. This image also provides a unique view of Lincoln High School from above at a relatively short distance, revealing architectural details such as the top of the auditorium turrets and the iron base of the flagpole atop the clock tower. At this date, Columbia Avenue (later to become Thirty-Seventh Avenue South) still runs into a dead end near the high school because of the densely forested gulch. G Street, at right, is home to both houses and businesses, with a few billboards visible to passing drivers. Students can be seen entering and leaving the school and sitting on grassy areas just outside the building's main entrance. (Courtesy of Tacoma Historical Society.)

This aerial photograph from August 1948 captures a slightly different angle, providing a view of Lincoln Park, substantially reduced in size from its original 40 acres but still home to both dense forest and cultivated gardens. The street with the curved drive at the top of the picture is Thompson Avenue, which borders the park to the west. (Courtesy of Tacoma Public Library.)

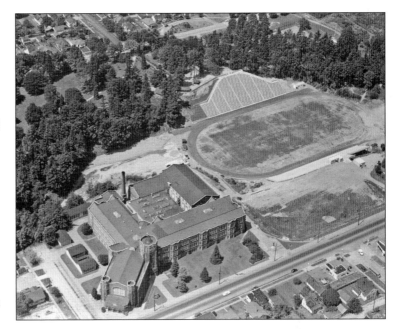

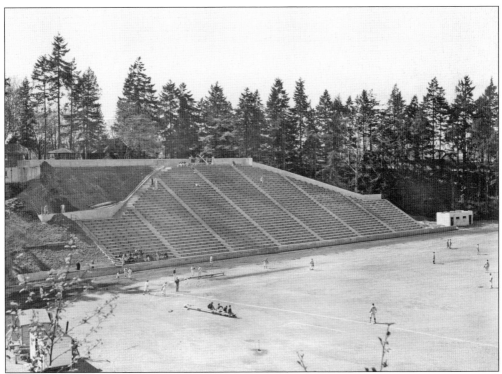

On April 30, 1948, a small number of spectators watch the Lincoln High School baseball team practice as work continues on the tiered seating on the west side of the Lincoln Bowl. It is clear from many of the photographs taken during the bowl's construction that Lincoln's sports teams did not cease or relocate during the project. (Courtesy of Tacoma Historical Society.)

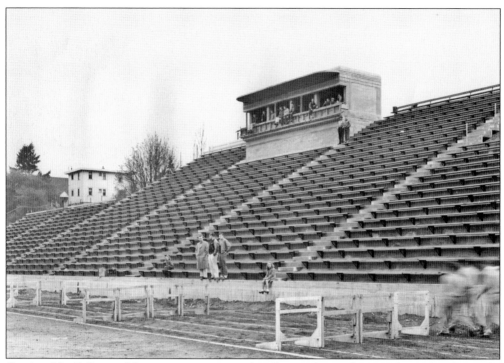

On April 9, 1948, as athletes practice running hurdles on the track, several people take in the view from inside the press box atop the east side of the new Lincoln Bowl. Work on the tiered seating appears to be complete, but the press box still has some of its construction framing in place at this date. (Courtesy of Tacoma Historical Society.)

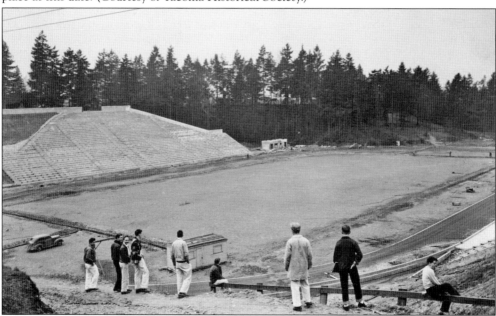

In February 1948, this photograph was taken for a feature article in the *Tacoma News Tribune* that recounted both the long wait for the completion of the Lincoln Bowl and some of the engineering challenges that went into the project. (Courtesy of Tacoma Public Library.)

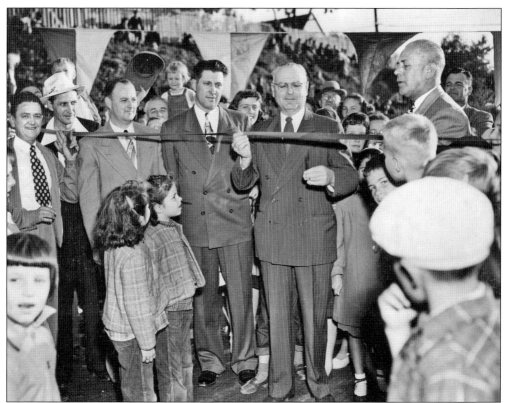

A crowd looks on as Tacoma mayor C. Val Fawcett is about to cut the ribbon formally opening a newly paved South Thirty-Eighth Street on June 17, 1949. The mayor stated that Thirty-Eighth Street would be one of the busiest crosstown streets in the city, and business owners in the Lincoln District were eager for the increased traffic. (Courtesy of Tacoma Public Library.)

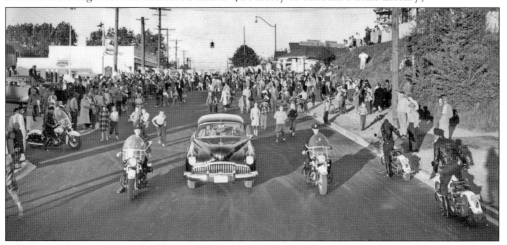

Following the ceremonial ribbon cutting, the mayor's automobile and accompanying police motorcade were the first vehicles to take advantage of the newly paved South Thirty-Eighth Street. Children run behind the vehicles as neighborhood residents of all ages watch from both sides of the street. The festivities were centered around the intersection of South Thirty-Eighth and M Streets. (Courtesy of Tacoma Public Library.)

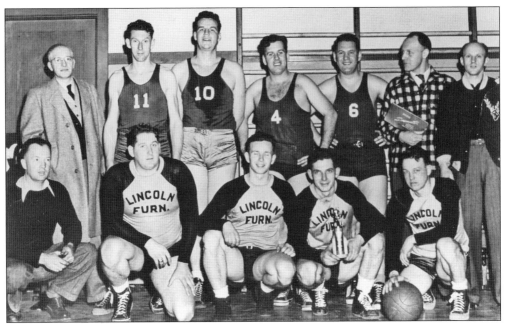

The Lincoln Furniture basketball team is photographed after winning the 1947–1948 Fraternal League title. Lincoln Furniture did business at 3730 South G Street and, like several other Lincoln District businesses, sponsored men's league teams in a variety of sports, including basketball, baseball, and softball. (Courtesy of Shanaman Sports Museum of Tacoma–Pierce County.)

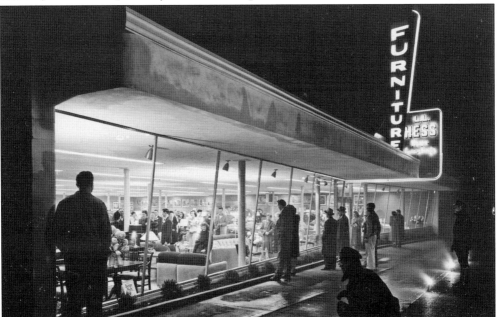

The L.L. Hess Furniture Company at 3830 South M Street celebrates the grand opening of its new store on November 18, 1948. The new building had a spacious interior and an ultra-modern setting. The L.L. Hess Company offered its customers top-quality merchandise, custom finished furniture, and prompt delivery service. The store, owned and managed by Laurence L. Hess, closed in 1959. (Courtesy of Tacoma Public Library.)

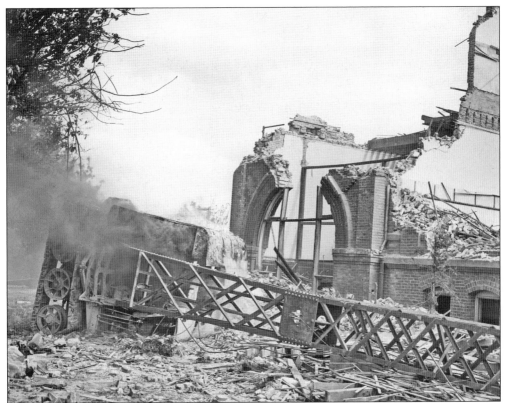

On June 22, 1950, the wrecking crane being used to tear down Whitman Elementary School, at 1211 South Fortieth Street, fell over near one of the arched entrances to the old school. Known as the "Big Red School House," Whitman was badly damaged by the April 1949 earthquake and had to be replaced. (Courtesy of Tacoma Public Library.)

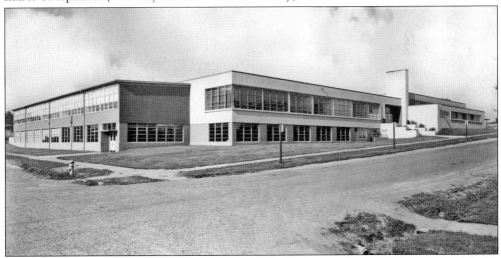

The new Whitman School was built in 1952 a few blocks away from its original site of South Fortieth and M Streets. Modern and sleek in design, it was very different from its 1892 brick predecessor. In 2012, the new Whitman was the first post–World War II school to be named to the Washington Heritage Register. (Courtesy of Tacoma Public Library.)

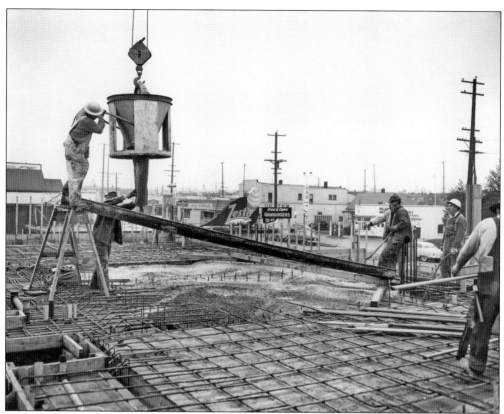

In March 1951, the new home of the Lincoln branch of Puget Sound National Bank was under construction at 3705 South G Street. The successful bank had outgrown its original home at 3808 Yakima Avenue. Looking south down G Street reveals a Zesto Hamburger stand, two service stations, and Lincoln Hardware. (Courtesy of Tacoma Public Library.)

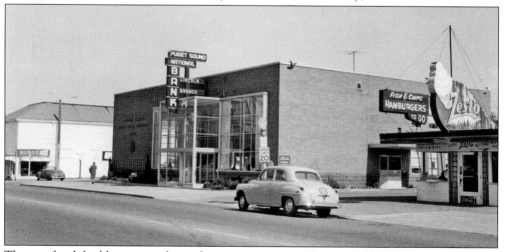

The new bank building is seen here after its opening in 1952. Its neighbor to the right is Zesto, advertising hamburgers, fish and chips, and ice cream by the cone, pint, or quart. At left is McKinnon's Department Store, occupying the large building on the northeast corner of South Thirty-Seventh and G Streets. (Courtesy of Tacoma Public Library.)

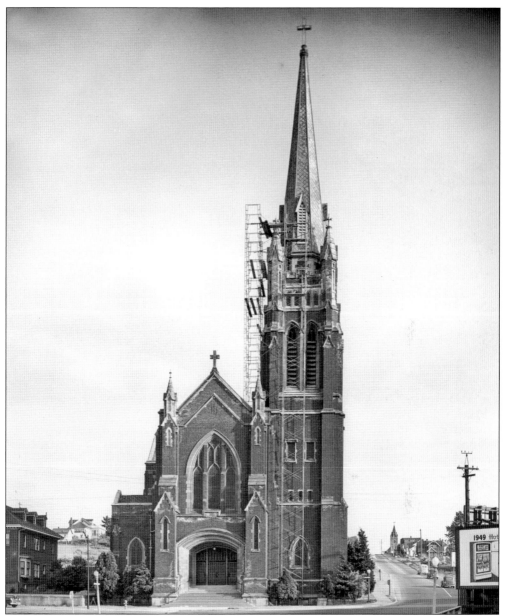

This front-on view of the exterior of the Holy Rosary Catholic Church with scaffolding set against its spire was taken on May 16, 1949, just a month after the devastating earthquake that damaged many buildings in the Puget Sound region, including some of the parish buildings. The Gothic-style church with its tall 54-foot steeple (270 feet from the ground to the top of the cross) fortunately did not receive any substantial damage. This photograph was taken from the Tacoma Avenue bridge over Galliher's Gulch, and Tacoma Avenue can be seen to curve to the right as it passes by the church and proceeds up the hill into the heart of the Lincoln District. In the distance is St. Joseph's Catholic Church, at the corner of Tacoma Avenue and Thirty-Fourth Street. A billboard at right advertises 1949 Hotpoint refrigerators. Just over a decade later, Interstate 5 would cut through this area behind the church, from left to right in this image. (Courtesy of Tacoma Public Library.)

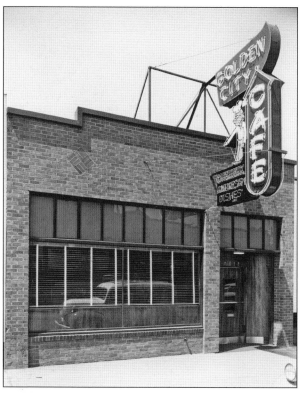

This building at 3812 Yakima Avenue South was originally constructed in 1932 as a post office. In 1951, the year of this photograph, it was converted into a restaurant, the Golden City Café, featuring a Chinese American menu. The business was originally owned by George Lew, Lung F. Louie, and Jung Git. (Courtesy of Tacoma Public Library.)

The interior of the Golden City Café shows a counter and stools along one side of the room and two rows of booths along the other side. Selection boxes for the jukebox can be seen along the counter. This photograph was taken on June 1, 1951, just before the restaurant's opening. (Courtesy of Tacoma Public Library.)

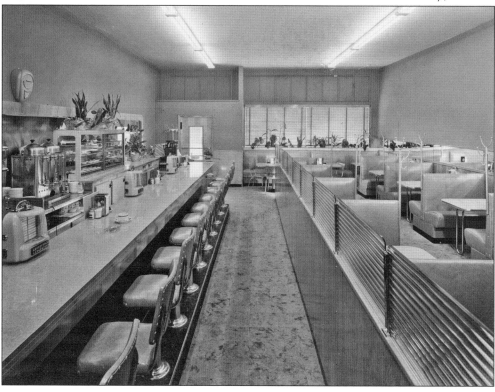

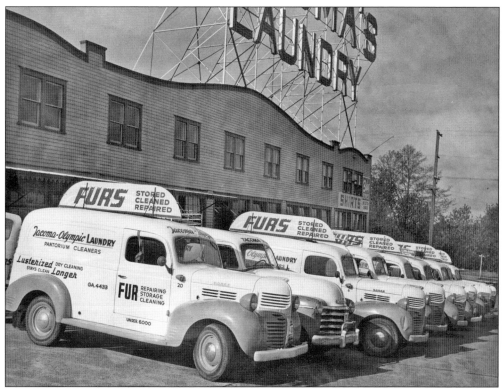

By May 1950, the large laundry facility on South Wright Avenue had been in business for more than half a century. At this point doing business as Tacoma-Olympic Laundry, the firm's vehicles advertise fur repair, storage, and cleaning as well as dry cleaning. The dramatic neon sign atop the building's roof advertises "Tacoma's Laundry" to the downtown area and neighborhoods to the north. (Courtesy of Tacoma Public Library.)

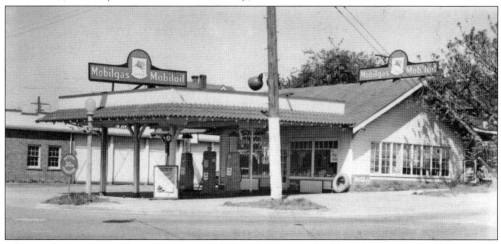

The northeast corner of South Thirty-Eighth and G Streets had long been occupied by a service station. This image from the late 1940s captures the original wood-frame building and old-style gas pumps. Within a few years, the building would be substantially remodeled, providing space for more vehicles and modernizing the pumps. The Mobilgas Pegasus, however, would remain. (Courtesy of Tacoma Public Library.)

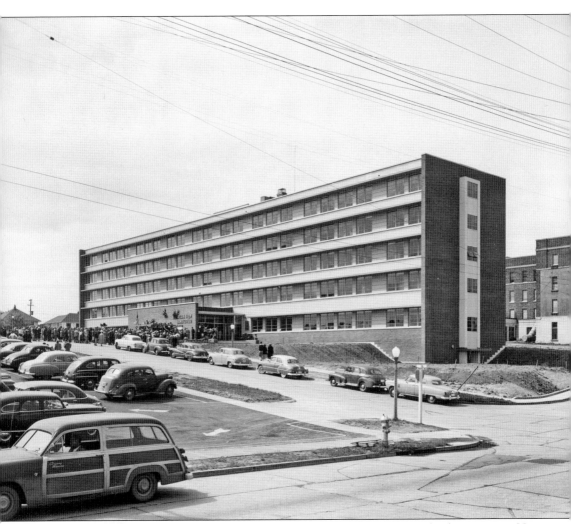

This photograph was taken on May 7, 1952, during the opening ceremonies for the Mountain View Sanatorium. Designed by Tacoma architect A. Gordon Lumm as a hospital for area tuberculosis patients, the sanatorium was one of the most modern and well-equipped facilities of its type when it opened. It was, at the time of construction, the largest single building expenditure in Pierce County history, costing $2 million. The sanatorium was next to the Pierce County Hospital for two reasons: money could be saved by using existing kitchen and laundry facilities, and it was determined that if in 10 to 15 years tuberculosis was under control, the facilities could be taken over by the hospital. The Pierce County Hospital did in fact absorb the sanatorium in 1958, and the combined facility was renamed Puget Sound General Hospital. In 2017, both buildings were demolished. (Courtesy of Tacoma Public Library.)

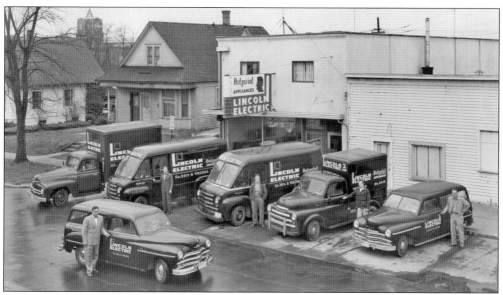

Tony Ricono, born Antonio L. Riconoscuito, became an electrical contractor shortly after graduating from Lincoln High School and started the Lincoln Electric Company after his Army discharge in 1944. The daytime photograph shows Lincoln Electric's first storefront, which opened in 1950 at 3737 Yakima Avenue. Ricono is in the foreground, and his workers pose with their vehicles. The nighttime photograph shows off the new store, which had its grand opening around the corner on South Thirty-Eighth Street in December 1952. As an electrician, Ricono made sure that his new building was fully wired. The building's many features included $15,000 worth of lighting fixtures; 57 miles of electric wiring; an intercom system; a music hook-up with 24 speakers; and over 500 electrical outlets to permit the most advantageous display of lamps and furniture. (Both, courtesy of Tacoma Public Library.)

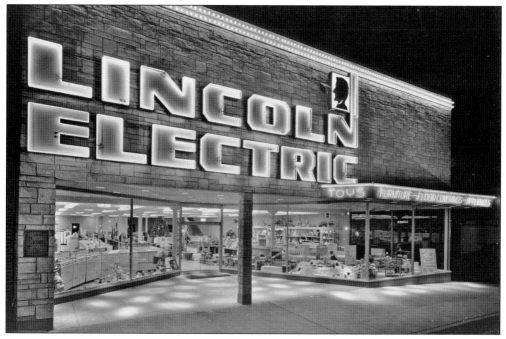

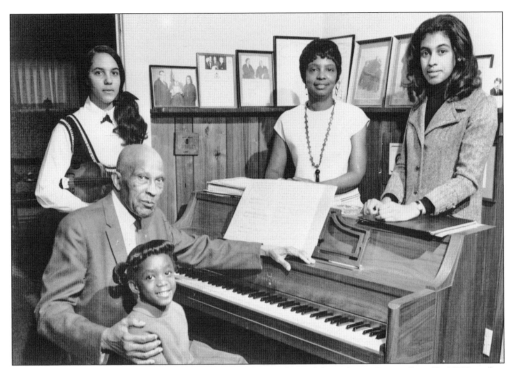

Ragtime great Joe Jordan (1882–1971) poses with family and friends on December 12, 1970, in his home in Tacoma. The composer, orchestra leader, and successful businessman relocated to the Pacific Northwest in 1944 at the age of 62, when the US Army invited him to join as a captain and, because of his musical expertise, to organize musical entertainment for black troops in the then-segregated military. Jordan enjoyed the area so much that he settled in Tacoma. Although no one in his family had attended Lincoln High School, he composed "Dear Lincoln" as a new alma mater for the school in 1949, and Lincoln choir director Margaret Goheen quickly built it into the repertoire for her students. (Both, courtesy of Tacoma Public Library.)

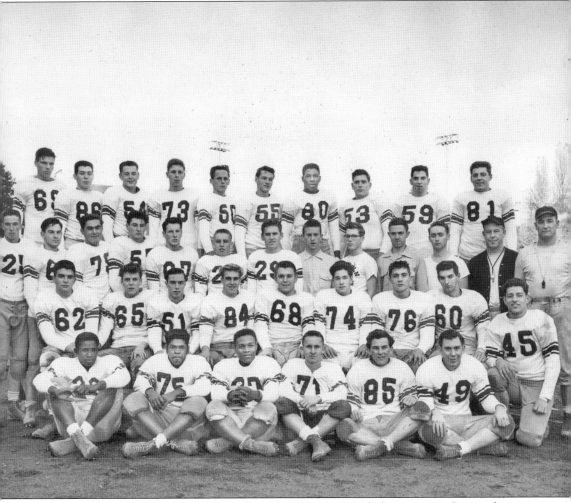

The Lincoln High School football team of 1953 is about to conclude its season. Senior players would graduate in 1954. According to the 1954 *Lincolnian* yearbook, the team placed first in the city and second in the Cross State League. After the season, fullback Jim Jones (No. 80, back row) was selected as the South Tacoma Kiwanis Inspiration Award winner by his fellow players in an almost unanimous vote. Lincoln's head football coach was Norm Mayer (right). Mayer was an all-conference guard for the College of Puget Sound in the late 1930s and began coaching at Lincoln in 1945. In 23 years at Lincoln, Mayer compiled a 140-50-6 record, making him one of only 12 Tacoma–Pierce County prep football coaches to win at least 100 games. He led the Abes to the city championship, the Cross State League title, and the state crown in 1948. (Courtesy of Tacoma Public Library.)

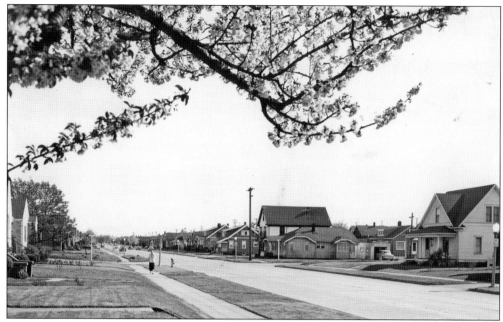

A cherry tree is in bloom in the foreground of this picture from April 28, 1954, which was taken by Tacoma's Richards Studio at the request of Lincoln Park Christian Church, just out of view at right. This view of South G Street, looking south from the middle of the 3800 block, shows well-kept houses with trim lawns. (Courtesy of Tacoma Public Library.)

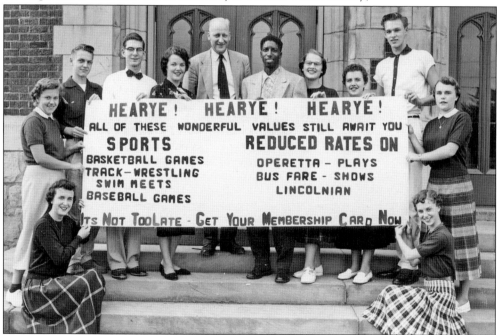

Eleven Lincoln High School leaders, along with the school's principal, stand on the steps of the school with a large banner promoting school spirit in September 1954. Principal Kenneth Flora is flanked by Sally Strobel, senior representative on the student council (left), and student body president Robert L. Simpson and Ida Kvenild (right). (Courtesy of Tacoma Public Library.)

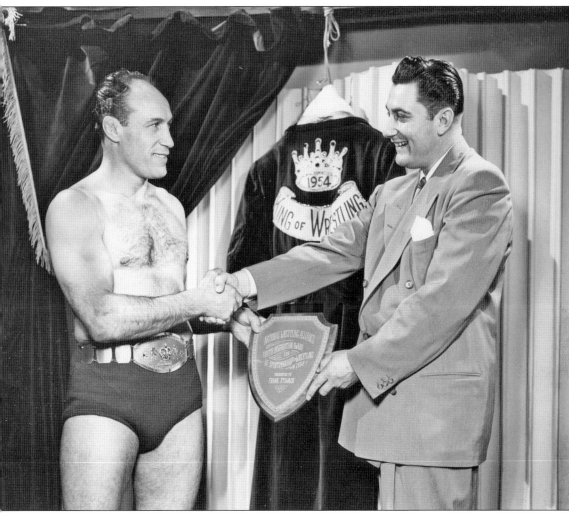

Frank Stojack (left) shakes hands with his brother, Pete, as they pose with a plaque from the National Wrestling Alliance, which had awarded Frank with the Youth Inspiration Award for 1952. By the time this photograph was taken in April 1954, Frank had won the light heavyweight title and was voted King of Wrestling by 112,000 fans. Frank Stojack began his illustrious athletic career at Lincoln High School, earning 13 letters. After graduation, he played football for Washington State College and the Brooklyn Dodgers in the National Football League. After leaving football, he moved back to Tacoma and took up professional wrestling. He continued to wrestle even after his election to the Tacoma City Council in 1953. At the end of his term on the Tacoma City Council, he was elected Pierce County sheriff. He served on the council and as sheriff from 1953 to 1962 and remained popular after leaving office. (Courtesy of Tacoma Public Library.)

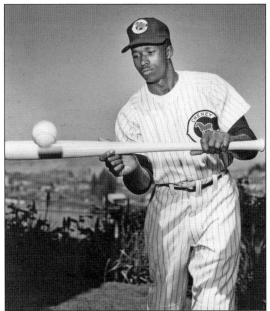

In June 1955, Luther Carr, who played for the amateur Washington Cheney Studs while still a student at Lincoln High School, demonstrates his bunting technique for the camera. Carr, a multisport talent, aroused the interest of several major colleges and professional teams. He turned down many professional sports offers after high school, choosing instead a scholarship with the University of Washington. (Courtesy of Tacoma Public Library.)

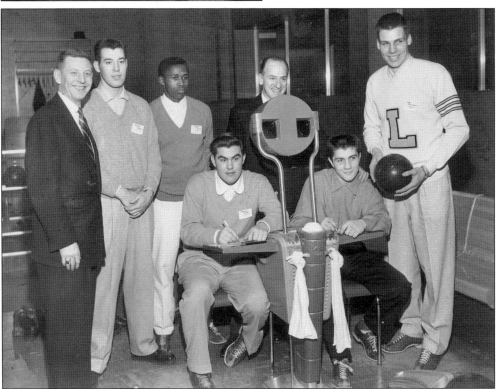

Several members of the Lincoln High School football team were recruited by the University of Washington (UW) in 1955. Pictured here from left to right are an unidentified representative of the UW Athletic Department, Duane Lowell, Luther Carr, Dennis Alder (sitting), John Cherberg (UW football coach), Jack Walters (sitting), and Joe Williams. (Courtesy of Shanaman Sports Museum of Tacoma–Pierce County.)

Maintaining a sportsmanlike atmosphere at athletic events and encouraging participation in all sports at all levels were primary goals of the Lettermen's Club at Lincoln High School. Three of the officers during the 1956–1957 school year are, from left to right, Jerry Cecchi, Dick Pruett, and Roger Coleman. All three lettered in two or more sports during their high school careers. (Courtesy of Tacoma Public Library.)

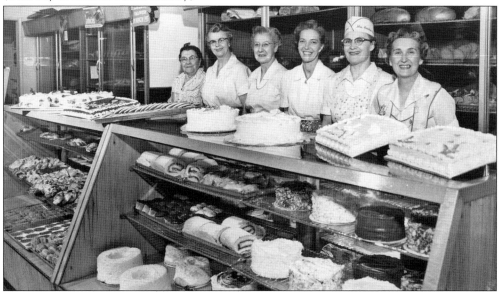

These women work behind the counter at Mrs. Frisbee's Bakery in November 1956. In 1930, Fred Frisbee purchased Alexander's Bakery at 710 South Thirty-Eighth Street and changed the name to honor his mother. The bakery quickly became a favorite stopping point for Lincoln High School students; although it changed ownership over the years, Mrs. Frisbee's was always known for fresh, scratch-baked quality. (Courtesy of Tacoma Public Library.)

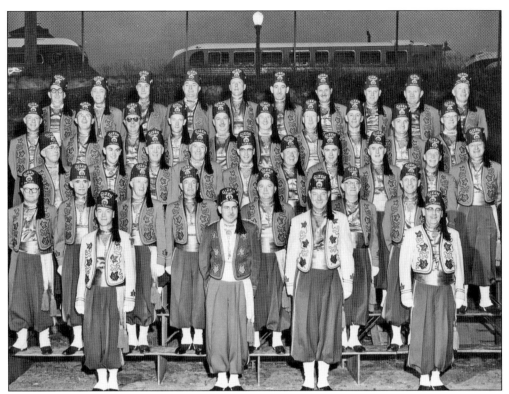

Gizeh Club members pose on the bleachers in the Lincoln Bowl as they await their turn to participate in Shrine ceremonies. Approximately 10,000 Shriners from Alaska to Montana attended the annual Pacific Northwest Shrine Association convention in early June 1957. Fourteen temples sent delegates, bands, uniformed patrols, and mounted units to Tacoma. (Courtesy of Tacoma Public Library.)

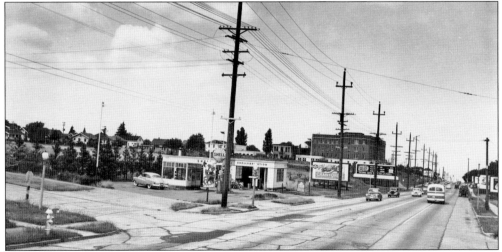

Several advertising billboards line Pacific Avenue north of its intersection with South Thirty-Seventh Street in this picture from August 2, 1950. Fred's Shell service station, owned by Fred Styf, is at left, with the Pierce County Hospital further down the block. The steeple of St. Joseph's Catholic Church can be seen in the distance to the left. (Courtesy of Tacoma Public Library.)

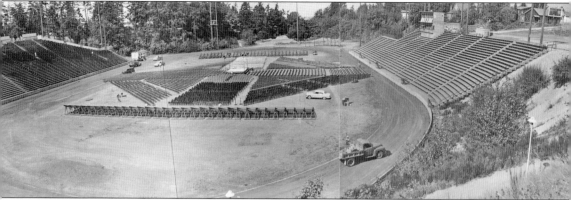

In 1956, boxing promoter Inigo Lucchesi organized two sold-out matches at the Lincoln Bowl for the Tacoma heavyweight fighter and Lincoln High School alum Pat "Irish" McMurtry. After graduating from Lincoln, McMurtry attended Gonzaga, and he later enlisted in the Marines during the Korean War. He won 103 of 105 amateur fights before turning professional in 1954 and would rise as high as No. 5 in *Ring* magazine's list of heavyweight contenders. Pictured is the setup for the August 24, 1956, bout between McMurtry and Willie Pastrano, who would go on to hold the world light heavyweight crown from 1963 to 1965. More than 11,000 attended the fight. Although McMurtry lost the match, he would go on to further successes, including his defeat of Canadian heavyweight champ George Chuvalo at boxing's shrine, New York's Madison Square Garden, in front of a national television audience. (Courtesy of Marc Blau.)

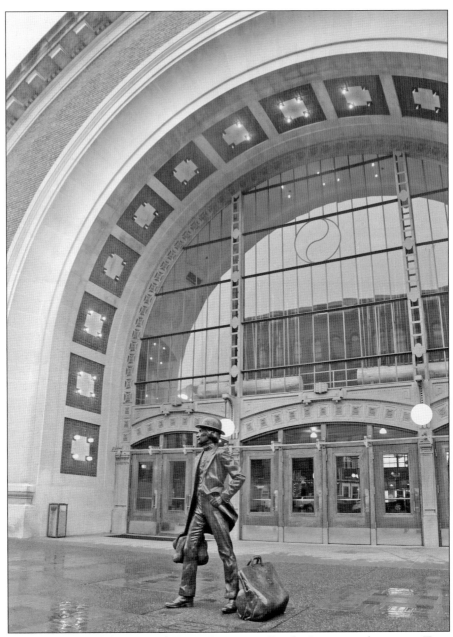

Gracing the exterior of the restored Union Station on Pacific Avenue in downtown Tacoma is *New Beginnings*, which depicts a man just off the train and looking forward to his new life in the West. The sculpture was created by Tacoma native Larry Anderson and dedicated in 1984 in honor of the city of Tacoma's centennial. Anderson was an honors graduate of Lincoln High School in 1958. He participated in a wide range of activities and sports while at Lincoln, ranging from the Honor Society and Art Club to the Lettermen's Club and Pep Club, and was a member of the varsity track, specializing in the pole vault. Anderson began his career as a teacher but later dedicated himself to his work as an artist; he now has more than 75 commissioned bronze sculptures to his credit, including several in Tacoma, as well as public art in cities and towns around the country. (Author's collection.)

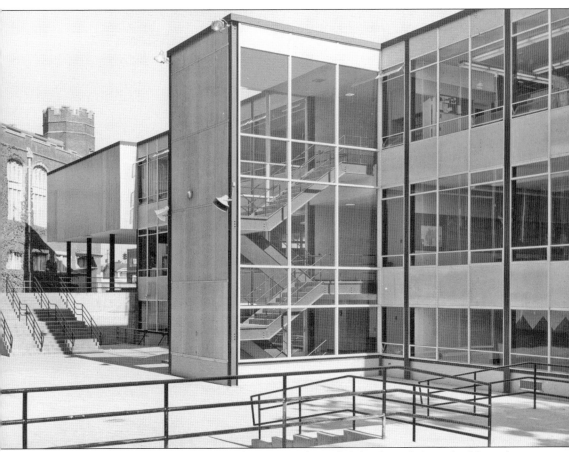

The glass-encased multistory fine arts building at Lincoln High School was dedicated in November 1957 and open for public viewing as part of the annual back-to-school night. The modernistic steel and concrete building was the first major addition at the school in several years. Tacoma voters approved a bond for the construction of the new building on May 10, 1955, in recognition of the lack of appropriate facilities at Lincoln for the school's large, successful programs in music, drama, and art. The student editors of the *Lincolnian* dedicated the 1956 yearbook to the citizens of Tacoma in thanks for their support of the project with the statement: "as every student needs a blueprint for his future life, he also needs buildings in which to study so that he might formulate these plans wisely." (Courtesy of Tacoma Public Library.)

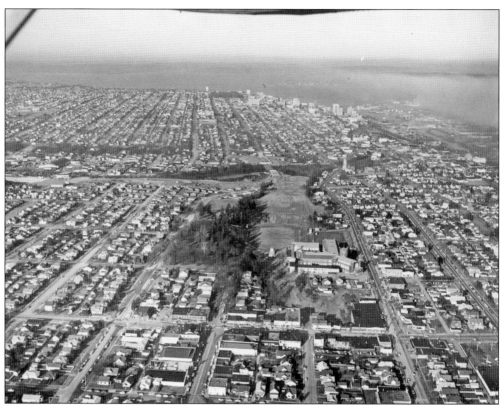

This aerial photograph of the Lincoln District, looking north towards downtown and Commencement Bay, was taken in 1961 to be included in the *Lincolnian* yearbook. Interstate 5 is in the process of cutting through Tacoma. Hood Street Reservoir, still visible at center, will soon be capped to make room for the new highway. (Courtesy of Tacoma Public Library.)

This photograph of the Lincoln High School drill team, Marcetta-Ki, appeared in the school's 1960 yearbook. The group performed at halftime during home games and marched in parades, including Tacoma's annual Daffodil Parade. According to the yearbook, girls with good posture, average grades, nice personalities, and good figures were chosen to be members of the club. (Courtesy of Tacoma Public Library.)

Five

REINVENTION, RENOVATION, REVITALIZATION

The 1960s would bring a range of significant changes to the Lincoln District. The construction of Interstate 5 through Tacoma in the early 1960s resulted in the removal of hundreds of houses, many at the north and west edges of the Lincoln District. In addition, the project significantly reshaped much of the land between downtown Tacoma and the Lincoln area, replacing what was once a forested gulch with a multilane highway. After traffic began flowing on the interstate, Tacoma Mall would open, attracting businesses and customers away from downtown Tacoma. Throughout all this physical transformation, the Lincoln District remained a centrally located neighborhood; South Thirty-Eighth Street, the heart of the Lincoln business district, had its own I-5 exits and became a convenient route to the mall.

The area would also witness significant population shifts that can perhaps best be understood through observing the change in the Lincoln High School student body. In 1962, the school was less than one percent African American. By 1975, that number was nearly 40 percent. Much of this change took place in the late 1960s, when many white families left the area, moving to new suburban developments, and families of color moved in to the neighborhoods served by Lincoln High School. Over the subsequent decades, the residents of the neighborhood, the school population, and the ownership of local businesses would become increasingly diverse.

This short book does not allow for an in-depth analysis of these changes; rather, this chapter will move quickly through the subsequent decades, providing some context for how the Lincoln District of the past transformed into the Lincoln District of today. The last few images tell stories from the very recent past: stories of Lincoln High School's 2007 renovation, which preserved its architectural heritage while preparing to serve future generations with excellence; stories of a business district with a newfound international flavor; and stories of teachers, students, business owners, and residents remaining rooted in a shared history while looking with renewed excitement toward the future of the Lincoln District.

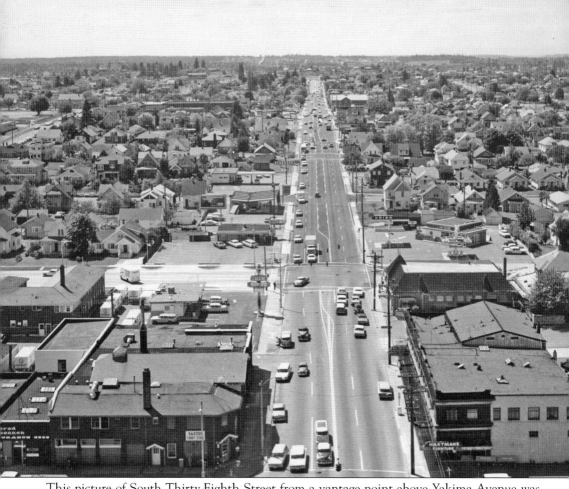

This picture of South Thirty-Eighth Street from a vantage point above Yakima Avenue was taken around 1968. Although most of the homes and many of the commercial buildings look very much as they would have earlier in the century, there are also some notable changes. Along the left side of Thirty-Eighth Street are two drive-in restaurants, Arctic Circle and Mickey's, the latter of which would be known as Jubilee within a few years of this photograph. Both restaurants were built in the mid-1960s as compact single-story structures with large parking areas. The large bakery facility at the corner of Thirty-Eighth Street and Yakima Avenue (bottom left) has just recently been vacated by Buchan's Baking, a longstanding Tacoma business, and now appears to be distributing Oroweat, a national brand, in large vans. The path of Thirty-Eighth Street has also been altered in the distance by the existence of the new Interstate 5. (Courtesy of Tacoma Public Library.)

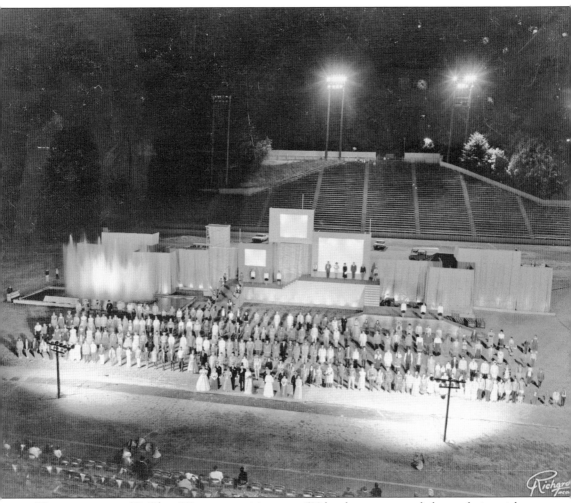

The gigantic cast of *By These Waters*, comprising some 593 locals, accepts accolades on closing night, July 5, 1969. The historical pageant, held at the Lincoln Bowl in honor of Tacoma's centennial, entertained audiences with 18 episodes and a grand finale. From the tiered seating on the east side of the Lincoln Bowl, attendees were able to get a good view of all the activity occurring on the custom-made 200-foot stage. The centennial events began with a June 28 parade that concluded at the bowl, where the Centennial Queen and her court of princesses—all women who resided in Tacoma—were announced. The Lincoln Bowl continued to be used for a variety of performances, including several summer concerts by local bands, during the 1970s, until the installation of athletic turf curtailed most nonsporting events. (Courtesy of Tacoma Public Library.)

This is the 3800 block of Yakima Avenue South as it appeared in the mid-1960s. Two young women are entering either Hamburger Haven or Rack & Cue, while signs in the distance advertise a beauty parlor and, at the end of the block, Lincoln Lanes Bowling Alley. Businesses on the opposite side of the street can be seen in reflections in the windows. (Courtesy of Tacoma Public Library.)

This photograph of South Thirty-Eighth Street between Yakima and Park Avenues shows the range of businesses that occupied the Lincoln District in the early 1960s. Several cars are parked in front of, from left to right, Callen's Lincoln Variety, Frisbee's Bakery, Beals Business Service, Larry Money Insurance, and Otto Tailor & Cleaner. (Courtesy of Tacoma Public Library.)

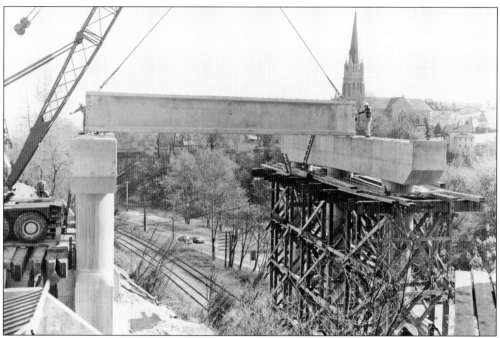

Woodworth & Co. workers are dwarfed by the size of concrete beams spanning Wakefield Drive (South Tacoma Way) and Center Street. The Yakima Avenue Bridge is under construction in April 1961, after voters approved a $1.5-million bond to finance the project. The steeple of Holy Rosary Church can be seen in the background. (Courtesy of Tacoma Public Library.)

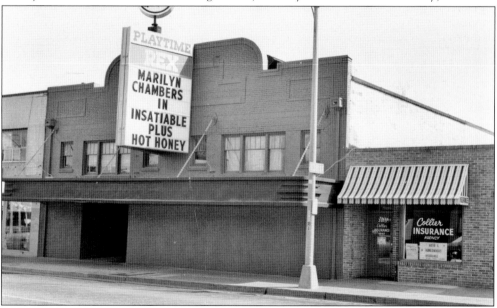

By 1980, when this photograph was taken, the aging Rex Theatre had been taken over by a Seattle businessman who specialized in turning failing neighborhood cinemas into adult movie houses. Among much protest from neighborhood residents and local religious leaders, this new venture lasted only a few years. The building would later be utilized as a church. (Courtesy of Tacoma Public Library.)

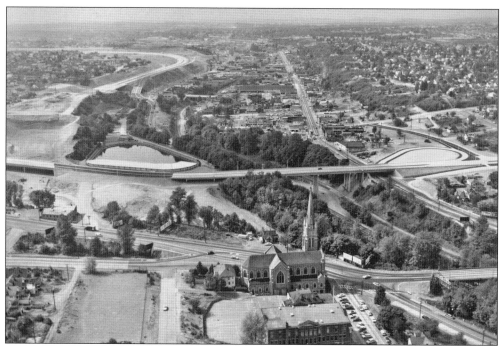

These two aerial photographs from 1961 reveal both the sheer expanse of the Interstate 5 project in Tacoma and the extent to which it would alter the Lincoln District. The new highway, as it curved through the center of Tacoma, required the removal of entire neighborhoods full of houses, the capping of the Hood Street Reservoir, the removal of a substantial amount of earth, and the building of several new bridges. The interstate passed just south of Holy Rosary Church and north of Lincoln Park and the bowl. Galliher's Gulch had once been a natural barrier between the Lincoln District and downtown Tacoma; Interstate 5 would add a man-made division. (Both, courtesy of Tacoma Public Library.)

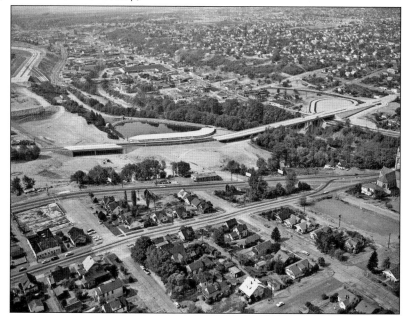

Three unidentified Tacoma youngsters pick up tennis tips from their volunteer coach, physician George Tanbara, during the summer of 1968 at the Lincoln Park courts. Although Lincoln Park had been substantially reduced in size over the past century, it was still frequently used for summer youth programs as well as the enjoyment of neighborhood residents. (Courtesy of Tacoma Public Library.)

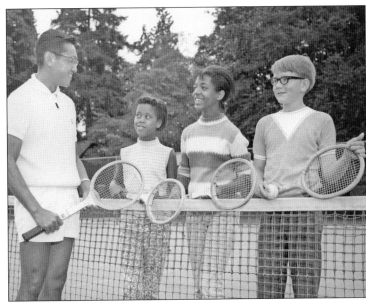

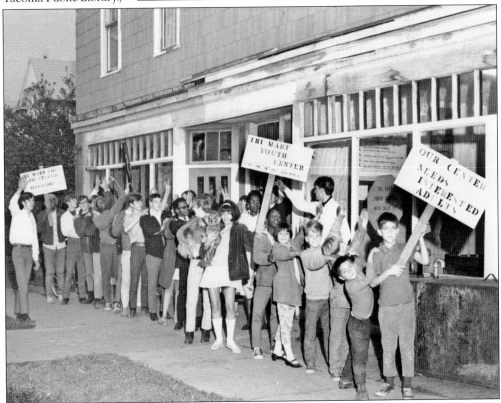

On November 14, 1968, a group of young children and teenagers form a picket line in front of the Tri-Mart Youth Center at 4515 South M Street. They are attempting to stir up interest in the youth center, where more adults are needed to help out. Leonard Butler, the center's director, believed that neighborhood adult participation was necessary for the growth of the center. (Courtesy of Tacoma Public Library.)

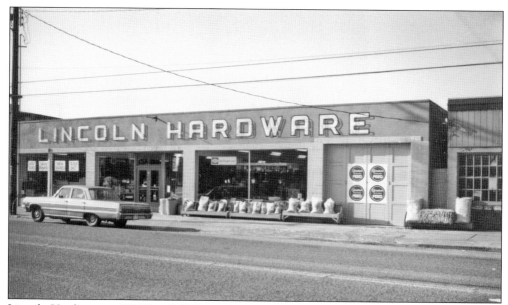

Lincoln Hardware, at 3726 South G Street, has seen very little alteration to its storefront over the decades, making it a constant in a business district that has seen much change. In fact, without the car in front to date this snapshot to the 1970s, neighborhood residents might believe it to be a current photograph. (Courtesy of Jennifer Feist.)

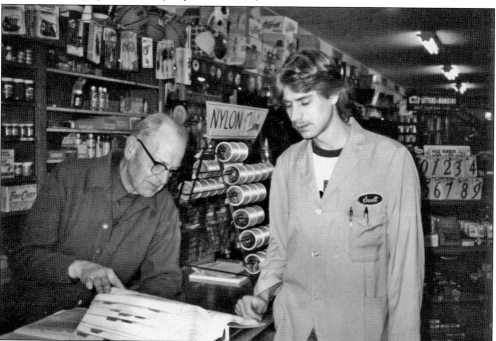

J.B. Feist opened this store in 1947 and passed it on to his son. It is owned and managed today by his grandchildren, Jennifer, Scott, and Dave. This photograph from the late 1970s shows J.B. and Scott looking over a supplier's catalog inside the store, which has always prided itself on providing friendly service to customers from the Lincoln District and around the city. (Courtesy of Jennifer Feist.)

On the heels of the *Brown v. Board of Education* decision and the Civil Rights Act of 1964, the Tacoma School District took voluntary measures to desegregate a select number of schools with high nonwhite enrollment, and Willie Stewart was selected to lead a summer counseling program to work with families on the transition between the closing of their neighborhood school and the new school of their choice. According to the US Commission on Civil Rights a decade later, the summer counseling program was pivotal to the success of the voluntary desegregation program in the Tacoma School District. In 1970, Willie Stewart was named principal at Lincoln High School, making him the first African American principal in the district. Stewart is pictured with an unidentified student in the 1973 *Lincolnian*. (Courtesy of Tacoma Public Library.)

Lincoln High School was the first school in the state of Washington to hire an African American teacher, Cornelia Lasley, in 1946. She taught math and headed the math department, remaining at Lincoln for 25 years until her sudden death in 1971. This picture appeared in the 1971 *Lincolnian* as a memorial to her years of service to the school. (Courtesy of Tacoma Public Library.)

Crossing the finish line for Lincoln in a 1978 relay race is Jacqueline "Jakki" Davis, class of 1979, who set school and meet records throughout her high school and collegiate track career. She specialized in the long jump and was also a member of several record-setting mile relay teams. (Courtesy of Shanaman Sports Museum of Tacoma–Pierce County.)

"Sugar" Ray Seales was a product of the Tacoma Boys Club amateur boxing program. In February 1972, he was named State Amateur Boxer of the Year and given a key to the city. Later that year, Seales won a gold medal in the 1972 Munich Olympics. He returned to Tacoma in 1973 and began his professional boxing career. After his retirement from the sport, Seales worked for 17 years at Lincoln High School, teaching life skills to special-needs students. In an interview after his retirement from Lincoln in 2004, Seales said of his students, "They learned from me, but it was more of an honor for me to learn from them." (Courtesy of Tacoma Public Library.)

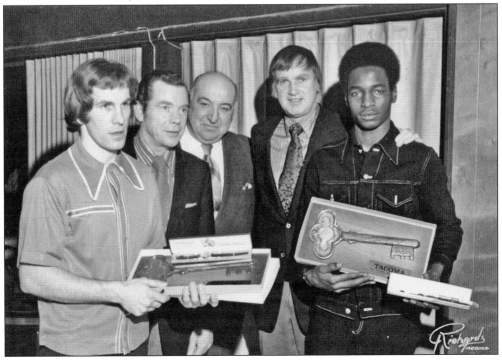

In 1970, Lincoln High School seniors Valerie Meyer and Charles Weatherby were elected by fellow students as Mary and Abe as part of Lincoln Week celebrations. The festivities also included a beard growing contest, a long-standing tradition at Lincoln. Bill Melton and Marty Burwash tied for Beard Most Like Lincoln's. (Courtesy of Tacoma Public Library.)

In the 1970s, Lincoln High School's forestry program, utilizing land in rural Pierce County that had been set aside as the Lincoln Tree Farm, flourished into a nationally recognized program. This yearbook photograph captures the group of students who participated in the Forestry Club during the 1970–1971 school year. (Courtesy of Tacoma Public Library.)

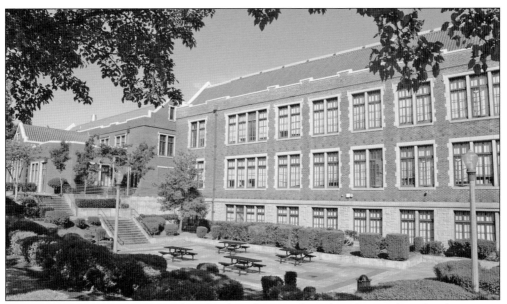

In September 2007, Lincoln High School students and teachers began the school year in a substantially modernized and expanded facility. During the 15-month, $72-million renovation, existing historic portions of the school were given structural upgrades and much-needed interior alterations. In addition, with the project architects paying great respect to the original architecture, two new wings were added. Pictured here are the seamless connections between the existing historic building and the new construction, with one wing added along G Street near the statue of Abraham Lincoln and the other along Thirty-Seventh Street. The school has received numerous awards in recent years, both for this physical renewal of the campus, and for a renaissance of its educational programs, modeled to serve the school's economically and ethnically diverse population. (Both, author's collection.)

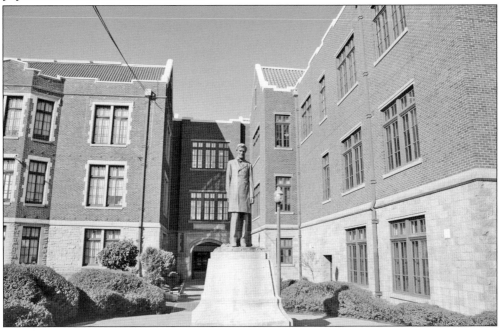

With the turn into the 21st century, the Lincoln District has become home to an increasingly diverse range of businesses, including many shops and restaurants with Vietnamese American ownership. Celebrating Tet, the Vietnamese New Year, has become a Lincoln District tradition. Kevin Le, Lincoln High School alum and owner of the Vien Dong Restaurant at the corner of Thirty-Eighth Street and Yakima Avenue, takes a photograph of the lion dancers and fireworks as the Tet parade passes by his business during the 2010 festival. Also in 2010, a young boy covers his ears while fireworks are set off as the festival crowd gathers in front of the Flying Boots Café, a longstanding Lincoln District business. (Both, author's collection.)

On September 23, 2015, Chinese president Xi Jinping visited Lincoln High School while on a trip through the region. Here, from left to right, are President Xi's wife, Peng Liyuan; Tacoma mayor Marilyn Strickland; President Xi; and Lawyer Milloy, a Lincoln alumnus who was a safety in the NFL for 15 seasons. (Courtesy of David Ryder.)

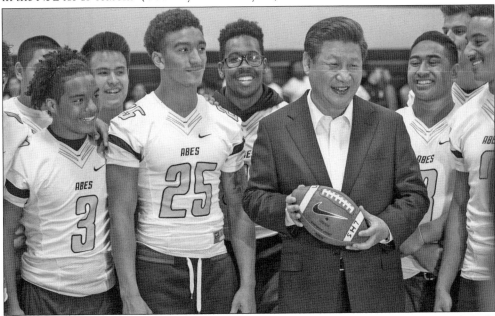

President Xi presented the students of Lincoln with many gifts during his visit, most significantly an invitation for 100 students to visit China the following year. Members of the Lincoln football team reciprocated, presenting Xi with a football and a custom jersey bearing his name and No. 1. (Courtesy of David Ryder.)

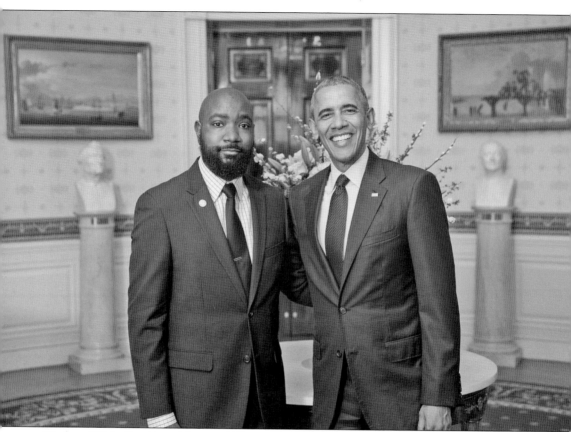

Nathan Gibbs-Bowling, Advanced Placement government and human geography teacher at Lincoln High School, was named 2016 Washington State Teacher of the Year. He is seen here with US president Barack Obama during his visit to Washington, DC, as one of four finalists for 2016 National Teacher of the Year. Gibbs-Bowling, a Tacoma native, is recognized for challenging his students to be actively engaged in the democratic process through action and critical thinking. Continuing a tradition established by some of the great teachers from Lincoln High School's past, Gibbs-Bowling's work extends beyond the classroom and campus. He mentors students through the College Success Foundation and helps organize tours to visit and support Lincoln graduates now in college. He continues to leverage the state and national attention paid to his teaching to raise awareness of issues facing his students and the Lincoln community. (Courtesy of Nathan Gibbs-Bowling.)

On May 19, 2017, community members gather at Lincoln High School to celebrate a new memorial to one of Lincoln's famous alumni: Medal of Honor recipient Col. Gregory "Pappy" Boyington. Marty Campbell, Tacoma City Council representative for the district that includes Lincoln, was chosen to unveil the memorial. Boyington, a 1930 Lincoln graduate who joined the Marine Corps during World War II, led a famous band of pilots dubbed the Black Sheep Squadron. Boyington was shot down over the Pacific, captured by the Japanese, and held prisoner for more than 18 months before he was released to a hero's welcome at home. He died in 1988 at age 75 and is buried in Arlington National Cemetery. JROTC students from Lincoln and Mount Tahoma High Schools, Lincoln alumni, and veterans' groups helped raise the funds for the monument. (Both, author's collection.)

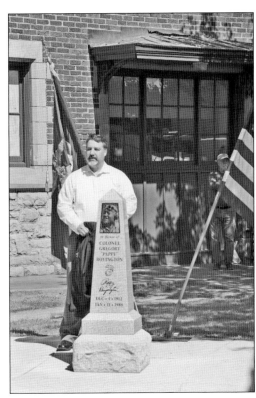

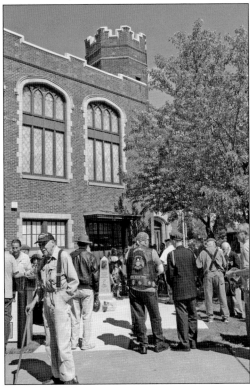

DISCOVER THOUSANDS OF LOCAL HISTORY BOOKS FEATURING MILLIONS OF VINTAGE IMAGES

Arcadia Publishing, the leading local history publisher in the United States, is committed to making history accessible and meaningful through publishing books that celebrate and preserve the heritage of America's people and places.

Find more books like this at
www.arcadiapublishing.com

Search for your hometown history, your old stomping grounds, and even your favorite sports team.

Consistent with our mission to preserve history on a local level, this book was printed in South Carolina on American-made paper and manufactured entirely in the United States. Products carrying the accredited Forest Stewardship Council (FSC) label are printed on 100 percent FSC-certified paper.

MADE IN THE USA